digital photography
problem solver

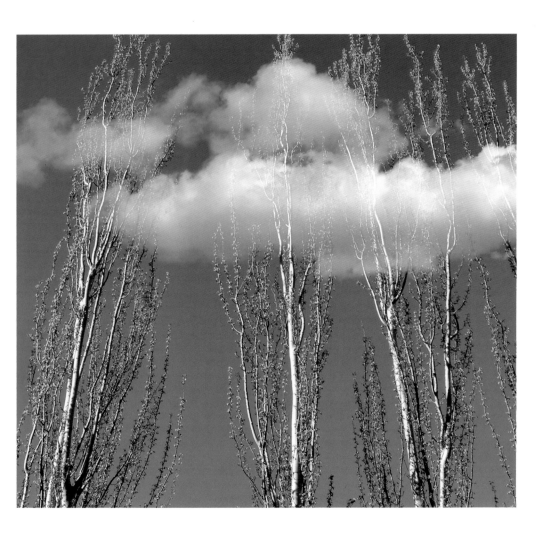

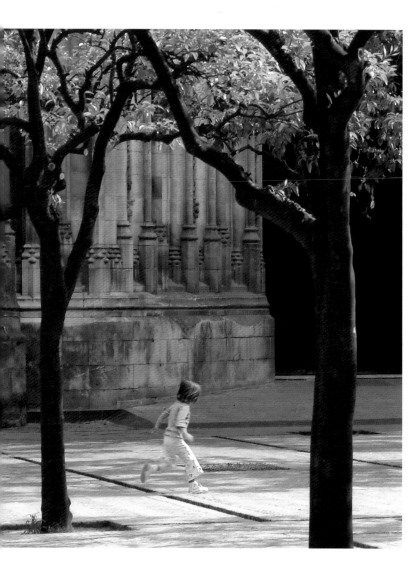

Les Meehan

digital photography
problem solver

The top **101** digital photography questions answered

COLLINS & BROWN

First published in Great Britain in 2005 by
Collins & Brown
The Chrysalis Building
Bramley Road
London
W10 6SP

An imprint of **Chrysalis** Books Group plc

Distributed in the United States and Canada by Sterling
Publishing Co.
387 Park Avenue South, New York,
NY 10016, USA

British Library Cataloguing-in-Publication Data:
A catalogue record for this book is available from
the British Library.

ISBN: 1-84340-168-1

Designed by Simon Daley
Edited by Beverley Jollands
Indexed by Richard Bird
Proofread by Fiona Corbridge

Reproduction by Classicscan Pte Ltd, Singapore
Printed and bound by SNP LeeFung in China

Contents

Introduction

Those people who have experience of traditional film-based photography beyond the 'happy snapper' stage will know that producing great pictures requires practical skills and technical knowledge from various creative and scientific disciplines. These skills and this knowledge require study and application if good results are to be obtained consistently and under the user's control. Digital photography and image manipulation is no different. What has changed are some of the disciplines from which we need to learn in order to obtain the knowledge we require.

Fortunately, most of the traditional practical photography skills are still essential in order to obtain a good photograph. Practical knowledge of things such as lenses, camera settings, exposure control and focus technique, are all traditional skills that are as important now as they ever were. Equally, the creative skills derived from artistic activity, such as understanding composition and colour theory, anticipating 'decisive moments', and 'having a good eye', are essential both when creating the original picture in the camera and when working with the digital image on a computer.

The difference now is that to be able to work successfully with digital technology it is important to learn new skills and acquire new

Evening flowers *Most of the traditional skills of photography are still required when creating digital images. One of the most essential skills is to develop a feeling for light and how it interacts with objects in the world around us. Interesting light can help to transform even the simplest of subject matter, as shown here.*

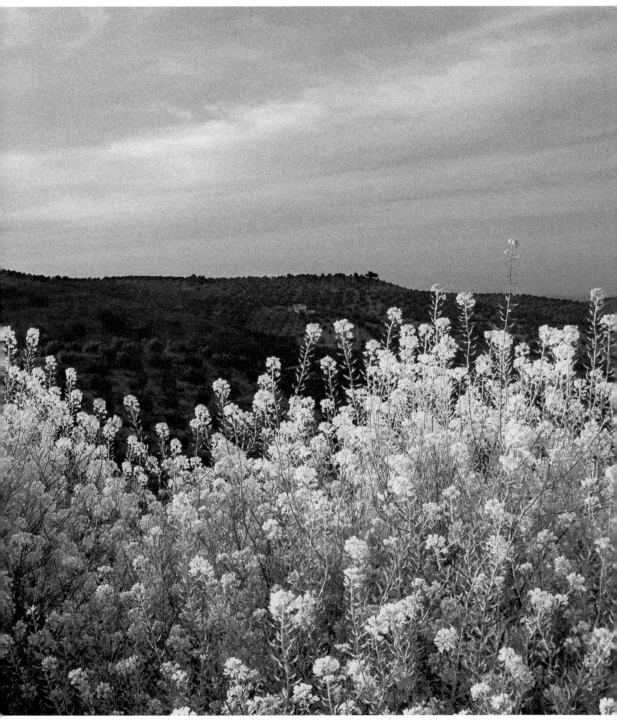

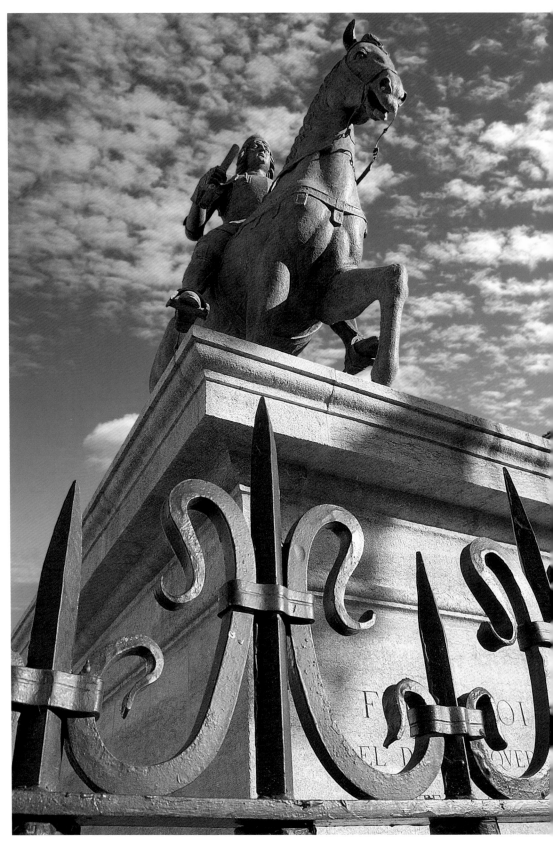

knowledge. Today, the modern digital photographer needs to know about computer equipment, pixels, megabytes, TIFF files, dye-based inks, specially coated papers and many other new things. On a professional level, the digital photographer needs to be more aware of the methods and processes used in the reprographic industry, in order to provide digital image files that are suitable for reproduction. Equally, for people doing inkjet printing at home, the situation is also very new. It is now necessary for the hobbyist digital photographer to understand about resolution, printing dpi, paper quality, and how to obtain the best from a photo-realistic printer in order not to waste costly printer consumables.

With the above in mind, this book is designed to help everyone involved in digital photography, from the complete novice to the more experienced practitioner. By bringing together a large cross-section of questions related to digital photography, from basic to intermediate and beyond, and organizing them into logical sections, this book forms a handy source of information and techniques. Depending on your experience, each section of the book can either be worked through from start to finish or dipped into to obtain the answer to a specific question. Alternatively, if you need help with a chosen practical technique, simply read the information with the relevant question. In this way, the book can be used as either a course in digital photography, or as a practical reference to keep close by when working on your digital creations.

Horseman *A simple combination of two images, the sky and the statue, made possible by the use of digital manipulation. Although montage has always been a part of photography, it is now much easier to combine multiple digital images to form complex pictures.*

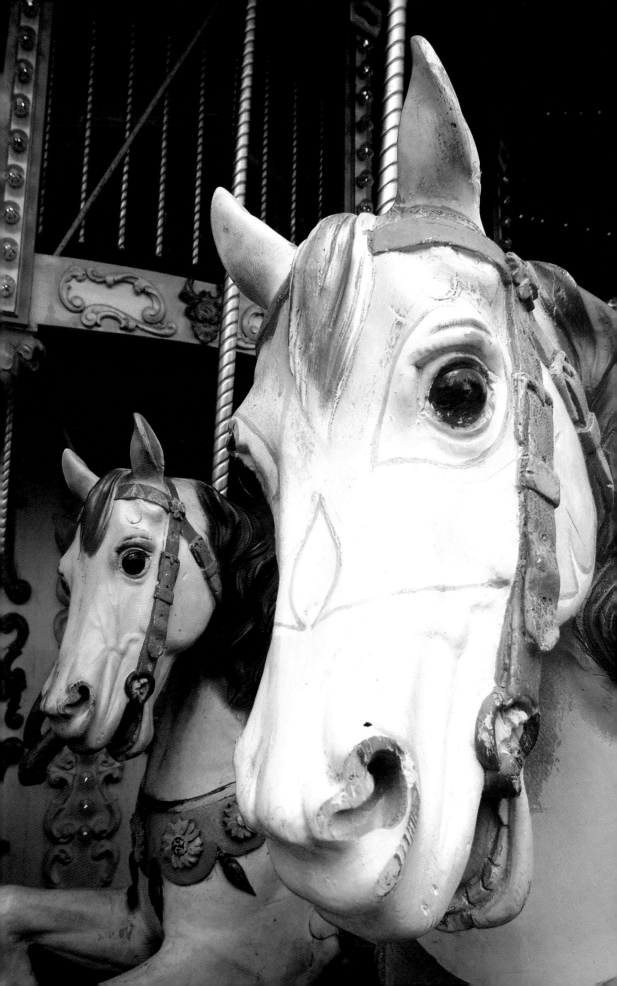

Chapter 1 | **Digital basics**

This first section of the book contains questions and answers relating to the technical aspects of digital image quality and the composition of digital image files. Although it is not essential to know everything about how digital files are composed, if you study these topics it will be easier to understand how the more advanced features of image-manipulation software work. This knowledge will be necessary when dealing with many of the concepts and techniques of more advanced creative imaging.

Don't be put off by the apparent technical nature of the questions in this section, because I have made all the explanations as easy to understand as possible without losing the essential know-how. This should make the text easy to read for even the most technophobic person. The illustrations will also help to reinforce the information in the text.

Carousel horses *Learning the basic technical aspects of digital imaging ensures that you, unlike these carousel horses, won't endlessly be going round and round in ever more frustrating circles.*

Picture quality

Q1 | What are pixels?

The image seen on a computer monitor is composed of tiny individual elements called pixels (derived from 'picture elements'). Each pixel has a unique colour, which is specified as a proportion of the three primary colours, Red, Green and Blue. By combining different amounts of each of the primary colours, almost any colour can be generated. Over time the use of the term 'pixel' has expanded and we now also use it in other contexts, such as when discussing the size of image files. A digital image is usually composed of millions of individual pixels. The smallest unit of data in an image file or on a computer monitor is one pixel.

Q2 | What does 'megapixel' mean?

'Megapixel' is a term that is used when specifying the amount of data a digital camera can record. It simply means 'a million pixels', so it is a manageable way of describing very large numbers of pixels. For example, a 4-megapixel camera is one that will produce 4 million pixels of image data (actually one megapixel equals 1,048,576 pixels).

1 Full-colour RGB picture
This colourful image contains over a million individual pixels, each of which represents one colour. The pixels are so small that they cannot be seen with the naked eye.

1a Picture elements – pixels
Enlarging a small section of the picture reveals the individual pixels and the colour and tone of each pixel. The various colours and tones blend into the smooth colours seen in the final picture.

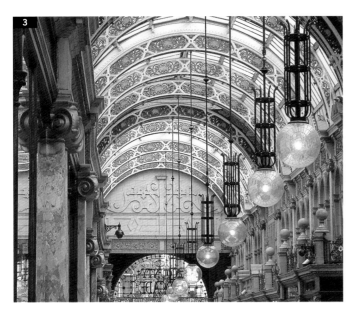

3 **Arcade interior**
This highly detailed subject benefits from the use of a lossless compression method, such as the TIFF format, to retain data integrity.

3a **Detail of TIFF file**
This enlarged section of the arcade picture, saved as a TIFF file, shows that the fine details of the original have been retained.

3b **Detail of JPEG file**
This enlarged section shows the loss of detail that occurs when the picture is saved using the JPEG format.

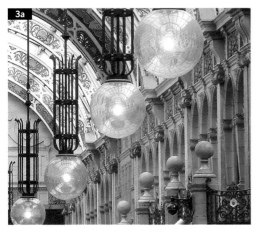

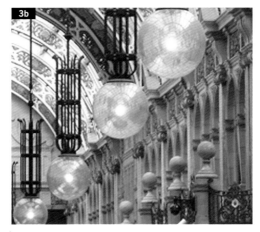

Q3 | What is picture quality?

The concept of picture quality can have different meanings, either visual or technical, depending on the context in which the phrase is used. In the case of digital image files, the technical picture quality is defined as a combination of the number of pixels in the image and the type and amount of data compression used when saving the file.

Generally, the more pixels a digital file contains, the higher the picture quality, since there is more data in the file. However, pixel count is only one factor in determining picture quality. The way in which the file is compressed will also affect the quality of the data in the file. Compression algorithms are known either as lossless (e.g. TIFF format) or lossy (e.g. JPEG format), depending upon whether or not the compression method discards some data from the file. The more lossy compression is applied to the image, especially in the camera, the more the picture quality will suffer.

4 **Native face – more pixels**

Resolution and image pixels are used together to determine the size of the final picture. This image has a pixel size of 1800 x 1455 and a resolution of 300 pixels per inch (or dots per inch). Therefore it has a print size of 6 x 4.85 in (152 x 123 mm).

4a **Native face – fewer pixels**

This version of the picture has the same resolution as the previous example, but the number of pixels in the file is much lower. The pixel size is 600 x 485 pixels so the final printed size at 300 dpi resolution is only 2 x 1.61 in (50 x 40 mm).

Q4 | **What is 'resolution'?**

'Resolution' is another term that is applied in various contexts but is generally used as a means of indicating how much detail an image will contain or display. Resolution is used at each stage of an image file's life. We can control input resolution when scanning, viewing resolution when displaying the image on a monitor, and output resolution when printing the image. It is usual to select the resolution of an image on the basis of its intended use. For example, images destined for use on the Internet will need less resolution than those intended for printing.

When you are scanning either film or prints, the scanner software may allow you to enter resolution values to control the level of image detail. Normally, the higher the resolution value, the greater the detail will be in the final scan. However, if you use a resolution value greater than the optical resolution of the scanner, the software has to generate artificial pixels (known as interpolation) to achieve the higher resolution value and the final image may actually contain less detail.

The resolution of a computer monitor can be raised or lowered (which changes the pixel size) resulting in items on the screen appearing either larger or smaller respectively. When an image is viewed at different monitor resolutions, the actual image file size remains unchanged. As an example, an image of 800 x 600 pixels will fill the screen of a monitor set to a resolution of 800 x 600. However, if the monitor resolution is increased to 1600 x 1200, the same image will now occupy only one quarter of the screen. Note that the actual image file size is still 800 x 600 pixels.

When images are printed with a desktop printer or professionally for books and magazines, the output resolution determines the size of the printed image. For example, an image of 1800 x 1800 pixels will produce a printed size of 6 x 6 in (152 x 152 mm) if printed with an output resolution of 300 dpi. The same image file would produce a print size of 12 x 12 in (304 x 304 mm) if printed at 150 dpi, but only 3 x 3 in (76 x 76 mm) if printed at 600 dpi.

Q5 | **What does 'dpi' stand for?**

Usually referred to in the context of printing digital images, 'dpi' stands for 'dots per inch'. Computer printers specify the quality of their output in terms of the number of dots of ink or pigment that can be printed in one linear inch. Thus, a 1440 dpi printer lays down half as many dots per inch as a 2880 dpi printer. Generally, the higher the dpi specified, the better the quality of output from a printer. However, although the printer may be capable of 2880 dpi, several dots of ink are required to produce the unique colour of each pixel. Therefore a 2880 dpi colour printer that uses 6 ink colours prints best with a file resolution of 360 dpi. It is recommended that for optimum detail and sharpness, the file resolution should be a factor

of the printing dpi, e.g. 180, 360, or 720 dpi for a 2880 dpi printer. This prevents the printer driver from performing unnecessary resampling (recalculation of the pixel data), which may reduce sharpness in the printed image.

When deciding which printer resolution to use – 1440 or 2880 dpi – it is sensible to take into account the image being printed. In many cases the difference in visual quality between an image printed at 1440 dpi and the same image printed at 2880 dpi is marginal because of the limitations of the human eye in detecting fine detail. However, the printing time will be substantially longer at the higher resolution.

Q6 | How are image file sizes specified?

Digital image file sizes are usually specified in one of two ways. The first system uses the actual amount of memory required by the image file, specified in megabytes (a byte is a measure of computer memory that can store a number from 0 to 256). Thus, a digital file may be specified as a 25 MB image, a 50 MB image or whatever MB size the file actually is (a 25 MB file will easily produce an A4 print).

The alternate method of specifying the file size of a digital image, used mainly by professional photographers and designers, is to use

7 Neptune uncorrected
This picture was saved in the camera as a RAW file and requires conversion to a different format for image editing. The image shown here has had no modifications applied to it during conversion from RAW to TIFF format. The accompanying screen grab shows the Photoshop RAW Converter dialog box.

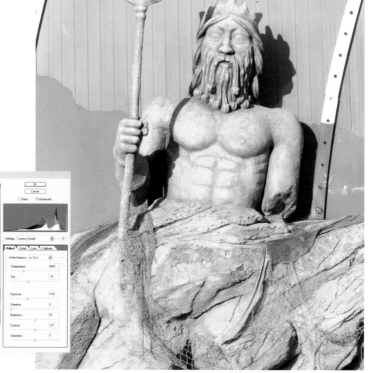

the actual pixel dimensions of an image. For example, the image size may be expressed as 3525 x 2475 pixels (this will produce an A4 print at a resolution of 300 dpi). This system is also used in the technical specification sheets of digital cameras, which specify the range of image sizes in pixels rather than megabytes.

For complete accuracy when talking about image file sizes, we should also specify the intended output resolution or proposed usage, whether Internet or print, since this affects the final output size of an image. However, it is now usual to omit this information since it is generally accepted that, unless otherwise specified, the resolution is 300 dpi, as used for professional print output.

Q7 | **What is a RAW file?**

Professional digital cameras allow the user to save the captured image without the camera software making any changes to the data produced by the camera sensor (the CCD). The 'raw' data that has been captured in this way is saved in a plain binary format known as the RAW format, which is usually denoted by the extension '.raw' in the filename.

Since the data stored in the file has not received any post-exposure

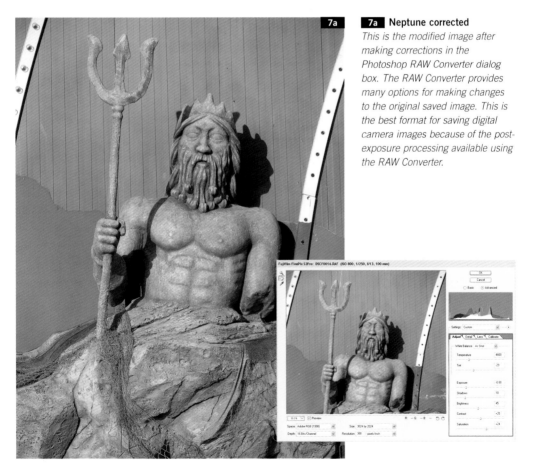

7a Neptune corrected
This is the modified image after making corrections in the Photoshop RAW Converter dialog box. The RAW Converter provides many options for making changes to the original saved image. This is the best format for saving digital camera images because of the post-exposure processing available using the RAW Converter.

changes, it provides the photographer with the maximum possible image quality and leaves all creative decisions, such as colour balance and final exposure level, to the user. Unfortunately, each camera manufacturer may produce its own specific RAW data file and so in order to make changes to the image, it is necessary for your image-editing software to be able to open the files produced by your camera. This is usually achieved either using conversion software supplied by the camera manufacturer, or a plug-in module for your editing software.

The latest versions of image-editing software, such as Adobe Photoshop, have RAW conversion built in and are able to offer full control over the data in a RAW file.

Q8 | What are colour spaces?

Colour spaces are scientifically formulated methods of quantifying colour. A colour space system allows each colour to be numerically specified so that exact colours can be chosen and repeated. The main colour spaces you will encounter are HLS (Hue, Lightness and Saturation), HSB (Hue, Saturation and Brightness), RGB (Red, Green and Blue) and CMYK (Cyan, Magenta, Yellow and Black – denoted by 'K' as it is the 'key' colour). The colours defined by each colour space vary due to limitations imposed by the method of producing the colour. For example, CMYK is the colour space used in the printing industry and is restricted by what can be achieved with printing inks and pigments. The RGB space – the commonest colour system encountered in digital photography – uses light, which allows a far greater range of colours than CMYK pigments. It is important to be aware of the different colour spaces you are operating with and the colour changes that may occur between your screen and the printout.

Q9 | What does 'gamut' mean?

'Gamut' is the term used to describe the complete range of colours that a particular digital imaging device or material can reproduce. Each device can reproduce only a subset of the full colour space available. For example, many computer colour monitors use phosphors to display colour and the gamut of a monitor is rather greater than the gamut of even a good printer, so your prints will always show fewer colours (but smoother tonal changes) than can be seen in the images on the monitor display.

Q10 | What is bit depth?

Bit depth or colour depth is a measure of how many unique colours it is possible for an image to contain. An image containing only black and white, such as a silhouette, requires only 1 bit for each pixel, so is known as a 1-bit image. (The term 'bit' stands for 'binary digit' and

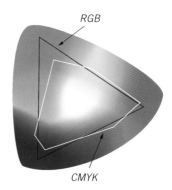

RGB

CMYK

9 **Colour space and gamuts**
This illustration presents a conceptual view of a colour space showing the full range of colours possible. The black and white lines illustrate the reduced gamut of the RGB and CMYK working spaces respectively. Notice that the RGB space allows far more saturated colours than the CMYK space.

10 **Full-colour 24-bit image**
For full-colour images such as this wooded landscape, the maximum range of colours is needed to capture the smallest changes of colour accurately. This 24-bit image contains over one million colours.

10a **Greyscale 8-bit image**
Up to 256 different tones of grey are available in 8-bit images. This detail, converted to greyscale, shows the variety of tones in the landscape image.

10b **Indexed colour 4-bit image**
Limiting the colours in the image to only 16 produces a 4-bit image. The conversion software has used whatever colours it could, resulting in the bright red of the tree turning orange-brown. Notice the lack of smooth tonal changes between the colours due to a lack of available colours.

10c **Black and white 1-bit image**
Reducing the colours to simple black and white produces a 1-bit image. Note that all tonal values have been converted to either black or white, with no smooth changes of tone.

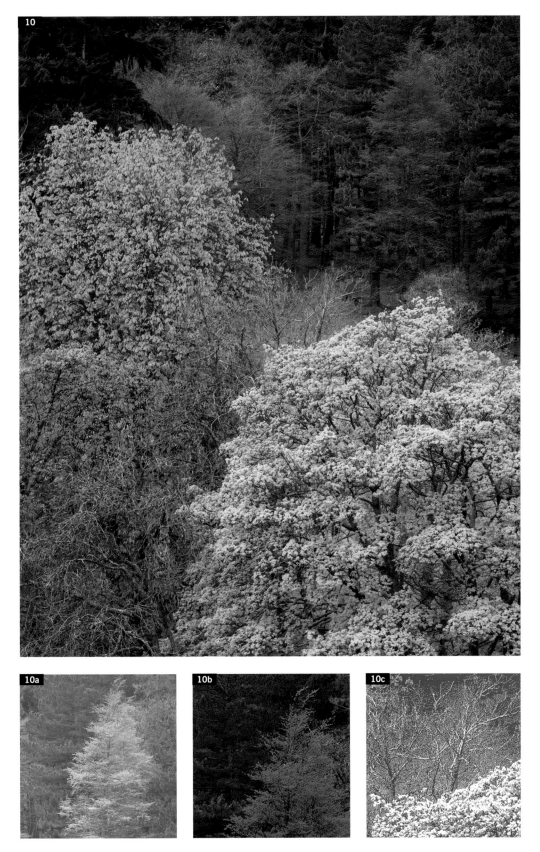

1 bit is the smallest unit of computer storage.) Greyscale images, such as black and white photographs, need 256 shades of grey to produce smooth tones and are called 8-bit images because they require 8 bits of storage per pixel. RGB colour images use 8-bit greyscale information for each colour channel, so require three times the storage of a greyscale image and are called 24-bit images.

Many image capture devices use higher bit depths, such as 48 bits, to extract more information from the original. These devices are using 16 bits per colour (based on three colours) to record the image. However, 48-bit images usually need to be converted back to 24-bit images for image processing, although high-quality software can do some work directly on 48-bit images.

11 **Daylight balance**

For general outdoor pictures the usual automatic white balance setting would be Daylight, as used here. This produces a natural colour rendition in most situations when the sun is shining. Other daylight settings may be available, such as Sunny, Shade, and Cloudy, to allow the user to obtain more accurate results in different lighting conditions.

11a **Tungsten balance**

Using the wrong white balance setting results in unnatural colours. This image of the same scene was recorded using the Tungsten white balance. This setting assumes that the subject is indoors and lit by normal room lighting, which would require correction by adding a lot of blue to the image. The incorrect addition of blue to this outdoor scene has distorted all the natural colours.

Q11 | What is white balance?

For traditional film-based photography, film manufacturers determine the colour response of their products based on the intended light source to be used when making the photographs. The most common film is known as 'daylight', since the vast majority of non-professional pictures are taken outdoors. Daylight film is also suitable for flash photography so it is used by many professional photographers. Professional photographers using incandescent lights (usually known as tungsten lights), or working in interiors without daylight or with mixed light sources, use tungsten-balanced film. There are other more specialized types of film, such as infrared and X-ray, which are colour balanced for specific purposes.

Because digital cameras do not use film, it was necessary to provide another method of producing acceptable colour pictures under different lighting conditions. Although the vast majority of pictures may be taken with either daylight film or flash, serious photographers require more control over the way a camera records the colours in a scene in order to cope with differing lighting problems. This is where the white balance control on advanced cameras comes into its own.

The white balance control allows the user to adjust the way in which the camera records the colours in a scene. The camera software adjusts the colour values of the captured data, based on the white balance setting, before saving the image. There are usually various preset settings for use in the most common situations, such as bright sunshine, cloudy but bright, overcast, and various types of fluorescent light for interior use. Most pro cameras also have custom settings, which allow the user to create a colour balance for a specific situation. This is useful in mixed light conditions when you want the best compromise or when it is critical to obtain the most accurate colour, such as in professional product or portrait photography.

Q12 | What are image artefacts?

In the course of producing a digital image, the image data may undergo many changes. Applying filters and other changes can produce unwanted results or the corruption of some of the pixels in the image file. These are known as artefacts.

The commonest source of artefacts is dust, either within the camera or picked up when scanning film or prints. Dust on the camera's sensor will result in blurred grey specks on your picture. Dust on scanned film will produce sharp-edged marks (either white or black). Another common source of artefacts is using compression when saving the file. If you need to use strong compression, always check the compressed image for artefacts and remove them.

The more extreme the changes made to a digital image, the more likely it is that artefacts will appear. It is good advice to check your finished image for any artefacts prior to final saving or printing.

12 **Dust and scratches**
This section of a picture shows artefacts commonly produced when scanning film, or from dust on the CCD of a digital camera. These marks are most evident in smooth areas of colour and must be removed before continuing to work on the image. Always view the image at 100% when looking for artefacts such as these.

12a & b **Compression artefacts**
This pair of images shows an enlarged section of a picture of a statue. Image 12a was saved with a lossless compression, while image 12b was saved using extreme JPEG compression.
Note how a definite structure has appeared on the second image: the picture is now showing severe compression artefacts.

Understanding and managing files

Q13 | What is a file format?

Many different types of information are stored on a computer and, although everything is stored as 0s and 1s, the information must be organized in a recognizable way in order for different computer programs to be able to understand it. Digital information organized in a specific way by a computer program when it is saved, is said to be in a formatted state. Hence, any file stored on a computer is in a specific file format.

The file format is usually dictated by the type of software the file is intended to be used with. For example, a word-processing file may contain mainly letters arranged into words and paragraphs, and a spreadsheet file may contain mainly numeric data, while a picture file will contain mainly colour data arranged in rows and columns representing pixels.

If you try to open a file format of the wrong type for the software being used, you will generally obtain an error message. For example, trying to open a Word document in Photoshop will not be possible. However, most programs contain conversion utilities that allow the program to open and save many different file formats of the same type. For example, Photoshop has its own file format (PSD), but can open other image file formats such as TIFF, JPEG, and many others.

It is a convention that each file format has a specific filename extension (three or four letters preceded by a dot) added to the end of the filename specified by the user. For example a Photoshop file might be identified as 'myfilename.psd', whereas a Microsoft Word file could have the name 'myfilename.doc' for a document, and so on. By checking the filename extension, you can usually determine what type of file you are dealing with. Most file types also have an associated icon to help identification when using a GUI (graphical user interface) such as Microsoft Windows or Apple's Mac OS.

Q14 | What does 'RGB' mean?

'RGB' is an acronym for the primary colours of light: Red, Green and Blue. Computer monitors use a combination of these three colours to produce all the different colours seen on the screen. Mixing different proportions of the three primary colours produces other colours. The colours can be specified using the RGB values, for example (R204, G51, B201) is a medium-tone magenta. This is especially important in digital imaging, since the only way to achieve smooth tone and colour changes in a digital picture is to be able to produce millions of different colours that can blend from one to the other. Each pixel of

14 **RGB colour synthesis**
This illustration shows a conceptual view of how the RGB additive colour system works. When two of the primary colours are added together they make a third colour, e.g. Red and Green make Yellow. Adding the three primaries together makes white light. The secondary colours Cyan, Magenta and Yellow are often referred to as Minus Red, Minus Green and Minus Blue respectively. The full range of colours is obtained by adjusting the tone and saturation of individual colours, as seen in the strip below the circles. Darker colours are called shades while lighter colours are known as tints.

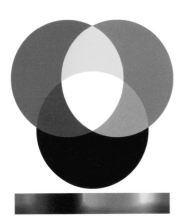

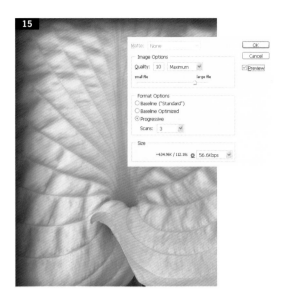

an image is assigned a unique colour based on the three primaries. RGB is also the name of a specific colour space (a range of colours) used for the majority of digital colour images.

We refer to digital photographs as RGB files (or, more specifically, RGB-TIFF or RGB-JPEG to denote the file compression used). The term can also refer to items of computer hardware (such as monitors) that use the RGB colour space. We say that these are RGB devices.

Q15 | **What does 'JPEG' mean?**

JPEG is a file format developed by the Joint Photographic Experts Group specifically to maintain the qualities of photographic images when saved as digital files. It is a very efficient lossy compression system that can be controlled to give the best compromise between image quality and file size. It is possible to reduce the stored size of a digital file quite significantly without sacrificing visual quality.

The JPEG format is useful when file size is critical for e-mailing or otherwise distributing image files. However, it is important to note that the JPEG system will compress the file each time it is saved, resulting in a progressive loss of quality. Always have an uncompressed master file (e.g. in TIFF format) and make any changes to this *before* saving with JPEG compression.

Q16 | **What does 'TIFF' mean?**

'TIFF' stands for 'tagged image file format', another system for compressing photographic images, but one that does not lose any data from the original file. This is known as lossless compression. The TIFF format is the most widely used by digital image-makers for saving the master copy of their work. Unlike JPEG files, TIFF files can be opened and saved as often as necessary without any loss of data.

15 **Leaf – JPEG format**
This picture and picture 16 each contain the same amount of image data, sufficient to obtain a print size of 5 x 4.15 in at 300 dpi resolution. Saving the image in JPEG format with a reasonably high quality setting of 10 (see screen grab) results in a stored file size of only 517 KB.

16 **Leaf – TIFF format**
This version of the leaf image was saved using the TIFF format with the LZW compression option chosen (see screen grab). The actual printed size and quality looks the same as for image 15, but the stored file size for this tiff version is a massive 5.36 MB. This is over ten times the storage required for the JPEG version. Of course, you can choose other TIFF compression options for greater efficiency.

Q17 | What is an image file?

An image file is simply the collection of stored data that represents some form of drawing or photograph. Image files may contain illustration work, digital paintings or photographic work.

A digital image is known as either a vector or a raster image, depending on the type of image the file contains. Vector images are created by illustration software such as Adobe's Illustrator or Corel's CorelDraw and are based on mathematical formulae; these do not require large file sizes when stored. Raster images are created by pixel-based software such as Adobe Photoshop, Procreate's Painter, Paint Shop Pro and other programs. Raster image files tend to be quite large due to the amount of data they contain.

The main difference between vector and raster images is that vector images can be scaled up or down indefinitely without affecting the file size too much and without any loss of quality in the image. Raster files, however, change size substantially as the image is scaled up or down and the image quality can change (i.e. deteriorate) dramatically as a result.

Q18 | How do I calculate file sizes?

It is useful to understand how to calculate the file size of a digital image and appreciate the relationship between pixels, resolution and scale (output print size).

Working in pixels, to calculate how much storage a basic uncompressed digital RGB file will need, start by multiplying the length of the image in pixels by the width in pixels to obtain the total number of pixels. Each pixel of a colour image requires three bytes of storage, so multiply the total pixels by three to obtain the total number of bytes in the file. (A byte is a unit of storage consisting of a sequence of eight bits.) To convert the total figure to megabytes (MB) divide by 1024 twice. For example, an image 1800 pixels long by 1500 pixels wide has a total of 2.7 million pixels (1800 x 1500 = 2,700,000). To find the number of storage bytes multiply by three, i.e. 2.7 x 3 = 8.1 million bytes. Now divide by 1024 twice to obtain the final figure of 7.72 MB.

To find the size of a greyscale image (a black and white photograph), you do not need to multiply the total pixels by three because greyscale images need only one byte of storage for each pixel rather than three. Thus, in the above example, the file size of a greyscale image measuring 1800 x 1500 pixels is only 2.57 MB. It is obvious from this that greyscale images are always one third the size of colour images of equivalent pixel size.

The ultimate file size of an image depends not only on the pixel size but also on whether the file contains additional layers and other items included by the editing software. These can increase the file size significantly.

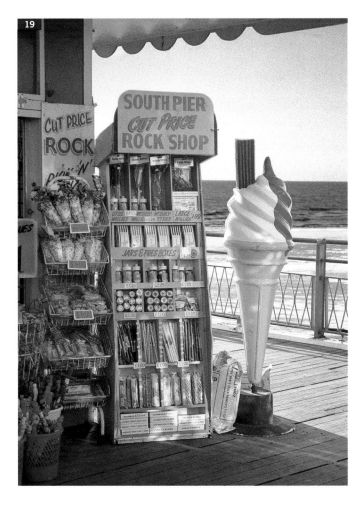

19 Rock stall on pier
Images with lots of detail such as this one compress less than images with large areas of smooth tone. Advanced compression software based on fractal technology, such as Altamira's Genuine Fractals (a Photoshop-compatible plug-in), generally compresses detailed images better. The file size of this 8 x 5.6 in (203 x 142 mm), 300 dpi image is 11.7 MB.

19a TIFF compression
This section from the main picture shows there is no loss of detail using the TIFF format, which is a lossless compression method. The file size of this 2.4 x 2.4 in (60 x 60 mm), 300 dpi section is 1.54 MB.

19b JPEG compression
JPEG allows various degrees of compression, which is useful for web graphics where file sizes need to be small. This version was compressed with a setting of 8 (the range is 1–12) and shows only slight degradation of the image details. The file size is only 236 KB.

Q19 | What is file compression?

Depending on the pixel size and quality, digital image files often contain vast amounts of information and require a lot of storage space. For example, an 8.3 x 11.6 in (210 x 294 mm) full-colour image at a resolution of 300 dpi requires at least 24.96 MB of storage. It is important therefore to have your pictures at the correct size for their intended usage in order to minimize the file size.

To reduce the storage problem, various methods have been developed to compress image data and produce smaller file sizes. The various systems used can be divided into two basic types, known as lossless and lossy compression.

Lossless compression, such as the TIFF format, reduces the file size without removing any of the original image data. Lossy compression, such as JPEG, is designed to reduce file sizes by removing data from the image in such a way that the impact on image quality is minimized. JPEG compression allows you to select different levels of compression so that you can control the resulting loss in quality. An important point about JPEG compression

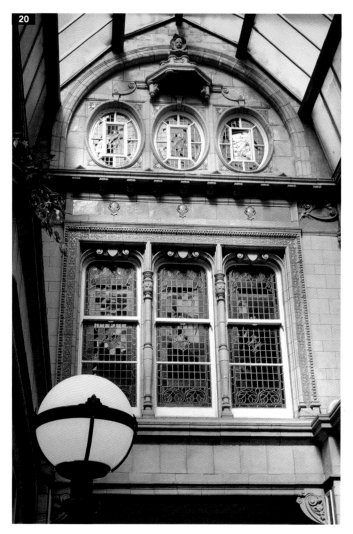

20 Arcade and lamp
This image, which was scanned from 35 mm film at the highest optical resolution of the scanner, is 12 x 8 in (304 x 203 mm) at 300 dpi and has not been interpolated. The file size is over 20 MB.

20a Reducing image size
This shows the same image after reduction in Photoshop to 5 x 3.5 in (127 x 88 mm) at 300 dpi. The file size has been reduced to 4.5 MB. Reducing the image size also makes the image appear slightly sharper.

20b Increasing image size
This is a section of the image after increasing the image size to 20 x 13.5 in (508 x 342 mm) at 300 dpi. There is obvious softening of details and an increase in the film grain in the final image (although this might not be so obvious here).

is that it is applied every time you save the image and hence more data will be lost and the image quality will eventually be badly affected. As a rule, you should never save a JPEG image more than once and you should always keep a TIFF version of your original image as security.

Q20 | What is 'interpolation'?

There will be many occasions when your image is the wrong size for the intended purpose. For example, you are often advised to scan film or print originals at the maximum optical resolution of the scanner. This produces large files that may need to be reduced at a later stage. Conversely, you may be working with an image that is too small for the intended purpose and needs to be enlarged.

'Interpolation' is the term used to describe the addition or removal of image data when changing image file size. When you enlarge a digital file the image software must estimate the values of existing

pixels to produce the colour values for new pixels that will be inserted between the original ones. Similarly, if you are reducing the file size of an image, the software removes certain pixels and interpolates the remaining pixels to hide the loss of data. In both cases, interpolation reduces image quality. However, it is better to reduce a file size than to increase it, since the loss of quality is always greater when enlarging an image.

Enlarging an image by interpolation also results in a softening of the image. This will need to be corrected later using the Unsharp Mask filter (USM).

Q21 | How many pictures can my camera store?

The number of pictures a digital camera can store is dependent on the capacity of the memory card in the camera, the pixel dimensions used and the quality level chosen for each picture. The larger the pixel dimensions of each image and the higher the quality level, the bigger each image file will be. The memory card has a fixed capacity so the number of photographs you can store on it will depend on the size of the picture files you create.

To calculate the number of images the memory card can store, you can simply divide the memory card capacity by the size of an individual image. Many digital cameras display the maximum number of images the memory card can hold based on the camera settings you have selected.

Unfortunately, most digital cameras are supplied with a memory card that has only a small capacity, such as 16 MB, and it is well worth upgrading to the highest capacity card you can afford so that you are not constantly running out of memory.

Storage capacity of camera media
This table shows the number of images media cards of different capacities can store, based on the pixel size and quality settings used on the camera.

Pixel Dimensions	6 megapixels 2832 x 2128				3 megapixels 2048 x 1536		1 megapixel 1280 x 960		VGA 640 x 480
Quality mode	HIGH	FINE	NORMAL	BASIC	FINE	NORMAL	FINE	NORMAL	NORMAL
File size	18 MB	2.4 MB	1.2 MB	460 KB	1.3 MB	590 KB	620 KB	320 KB	130 KB
Memory	Standard number of shots								
16 MB	0	6	13	33	12	26	25	49	122
32 MB	1	13	28	68	25	53	50	99	247
64 MB	3	26	56	137	50	107	101	198	497
128 MB	7	53	113	275	102	215	204	398	997
256 MB	14	106	226	550	204	430	408	796	1994
1 GB	59	43	938	2190	842	1729	1642	3285	8213

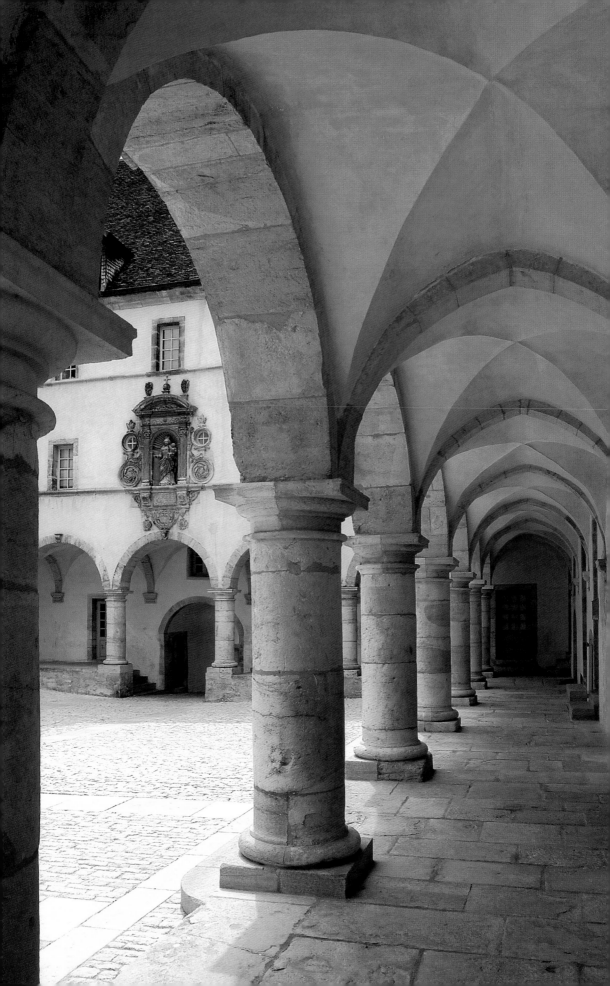

Chapter 2 | Using a digital camera

In this section the questions are concerned with digital equipment and some techniques for actually making pictures. The equipment questions are designed to familiarize even the complete novice with various important aspects of digital cameras and digital image storage. The picture-making techniques are based on what you can do at the camera stage to make sure you obtain the best original to be used for later manipulation.

Most of the technique-related questions are based on traditional photography methods because these are still relevant whether you are using a traditional film-based camera or an ultra-modern digital camera. Some of the techniques may be familiar to readers with previous experience of film-based photography. However, other topics covered are unique to digital imaging and will therefore be new to everyone, irrespective of previous photographic experience.

Convent arches *Learning to use your digital equipment is relatively simple; the more difficult task is to learn to see interesting pictures in everyday subject matter. This deceptively simple picture of an old courtyard relies on the compositional elements of shape repetition, perspective, line and colour harmony to provide visual interest.*

Equipment

Q22 | What equipment is needed for digital photography?

The only essential piece of equipment required for digital photography is a digital camera. Just like traditional film-based photography, you can snap away with even the simplest digital camera then take the memory card into your local print shop for digital printing.

After a digital camera, the next item on most people's equipment list would be a printer. There are digital printers available to suit all budgets and several models have memory card slots so you don't need to own a computer to make your own prints. Some cameras can be attached directly to a dedicated printer to make prints straight from the camera itself.

However, to experience all the fun and excitement of digital photography, the best option by far is a photo-quality colour inkjet printer connected to a computer. This puts a computer high on most people's wish list. Even the simplest digital image editing requires quite a lot of work by the computer so it is always a good idea to buy the best computer your budget allows. Apart from needing a fast processor (CPU), the computer will also need a reasonable amount of memory (at least 512 MB of RAM) and plenty of storage capacity on the hard drive. This is because digital image files

22 Essential equipment
To fully appreciate and explore digital imaging it is essential to have a digital camera, a computer and a photo-realistic printer. Choose the best equipment your budget will allow, especially for the camera and printer, since these dictate the quality of your results.

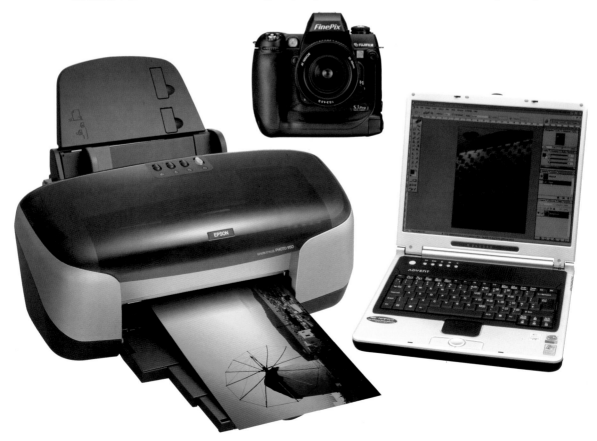

tend to be quite large (for example, an A4 colour print requires a file of at least 25 MB).

You will also need a good image-editing program. These range from reasonably priced packages such as Paint Shop Pro and Adobe Elements 2, to professional-level software such as Adobe Photoshop.

Q23 | What is a digital camera?

A digital camera is similar in appearance to a traditional camera, but it does not use photographic film to capture the image projected into the camera by the lens. Digital cameras have replaced the need for film with an electronic device that creates an image. The image is processed by the camera's built-in software and then recorded on some form of storage device.

Since the captured picture is in digital form, many alterations can be made to the quality of the image prior to saving the digital file. For example, depending on the facilities provided by the particular camera, it is usually possible to change the contrast, overall colour and sharpness of the picture either before or after it has been taken. This and many other facilities are simply impossible on traditional film-based cameras.

For most users, the main advantage of a digital camera over its film-based counterpart is that each picture can be examined on a preview monitor, usually on the back of the camera, immediately after being taken. This instant feedback allows you to retake the shot if necessary to make improvements or correct any mistakes, such as chopping off the tops of people's heads!

23 **Compact cameras**
There are a vast number of different compact cameras to choose from and many are in one of the two styles shown here. The upper model is of the SLR style while the lower model is a rangefinder camera. All digital cameras have a host of features and the one you choose is limited only by your budget.

Q24 | What is a digital compact camera?

Digital cameras can be organized into two main groups: those with a fixed lens and those with interchangeable lenses. The group of cameras that have a fixed lens are known as compact cameras because, generally, fixed-lens cameras are smaller and lighter than their interchangeable lens stablemates.

Most compact digital cameras have a zoom lens attached and although this often provides all the range the average holiday snapper requires, it can become too limiting if the user wants to explore photography more seriously.

In the past, one of the main problems of compact cameras has been the fact that you usually view the scene through a viewfinder that doesn't show the actual scene the taking lens will record. This can lead to framing problems (because of the phenomenon known as parallax error), of which the commonest example is decapitation of people's heads in close shots. However, many digital cameras allow this problem to be overcome by showing the scene on the preview screen at the back of the camera before the picture is taken. This is why you often see people holding their camera out in front of them

rather than holding it close to their eye for viewing.

Digital compact cameras represent the widest range of cameras from each manufacturer. From the most basic models through to the more expensive sophisticated examples (with lots of interesting facilities), there is usually something for everyone in terms of price and performance.

Q25 | **What is a digital SLR?**

The acronym 'SLR' stands for 'single-lens reflex' and it applies to the range of digital cameras that allow the user to see in the viewfinder the same image that will be recorded by the CCD (see Q26). The advantage of this over non-SLR (e.g. compact) cameras is that it is easier to obtain accurate framing of the subject. However, an important point is that the viewfinders of nearly all SLR cameras show only around 95 to 98 per cent of the actual picture recorded. This means it is quite possible that there will be things around the edges of the picture that you couldn't see in the viewfinder when you made the picture but which may spoil the resulting photograph (although the annoying edges can easily be cropped off later).

Generally, SLR cameras have interchangeable lens systems that allow a wide range of different lens focal lengths to be used on the camera. This enables the user to expand the camera's capabilities for

25 **Digital SLR camera**
This picture shows a professional digital single-lens reflex camera. This camera type is the most versatile, and professional models are usually supported by a large system of lenses and accessories to suit every need.

more serious photography. However, many of the sophisticated higher-specification digital compact cameras now have through-the-lens viewfinders, which makes accurate framing possible even though they are of fixed lens design.

Q26 | What is a CCD?

'CCD' stands for 'charge-coupled device' and is an acronym for the electronic device used in digital cameras to capture the image. The CCD replaces the film used in traditional non-digital cameras. A digital camera's CCD is made up of millions of individual photodiodes, which respond to the light and dark areas in the subject of the photograph. Each light-sensitive photodiode produces a minute electrical signal that is proportional in strength to the amount of light striking it. The more light the photodiode receives, the more electric current it generates. After the exposure has been made, the millions of electric currents produced by the CCD are analysed and processed by the camera's built-in software to produce an image of the subject that was photographed.

Since photodiodes are not colour-aware, the CCD requires a mosaic-like pattern of Red, Green and Blue filters over it to filter the incoming light from the subject in order for the software to analyse the colours in the scene. The CCD also has a top layer of minute lenses that focus the light directly on to the individual photodiodes to improve the image quality.

26 Fuji Super CCD
Uniquely, Fujifilm cameras are equipped with a CCD that has a distinctive octagonal shape rather than the more usual square or rectangular shape. The concept behind this approach is that the octagonal shape allows more subject information to be recorded and improves the smoothness of tone created by the camera software.

Q27 | What is an electronic viewfinder?

One of the advantages of digital camera technology is that the image, formed by electrical current and processed by software to form a visible picture, can be displayed on a miniature LCD (liquid crystal display) screen in the viewfinder of the camera. This type of viewfinder is known as an EVF, or electronic viewfinder. It enables the photographer to see a digital picture of the subject as it is seen by the camera lens. The main disadvantages of an EVF are that the display has less clarity than an optical system and, since it needs to be powered, its use reduces battery life. Another potential irritation of this type of viewfinder is that since the image needs to be constantly updated by the software as the camera lens is moved around the scene, the image being viewed can appear jerky.

Q28 | What is an optical viewfinder?

Digital cameras may have either an EVF or an optical viewfinder to allow the user to frame the picture prior to exposure. Optical viewfinders use a simple lens system to provide the user with an image of the scene in front of the camera. Since optical viewfinders are using lenses to show the user the scene they are usually brighter, sharper and steadier than their EVF equivalents (another

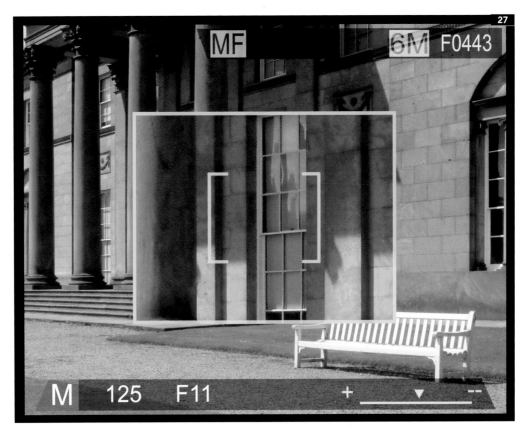

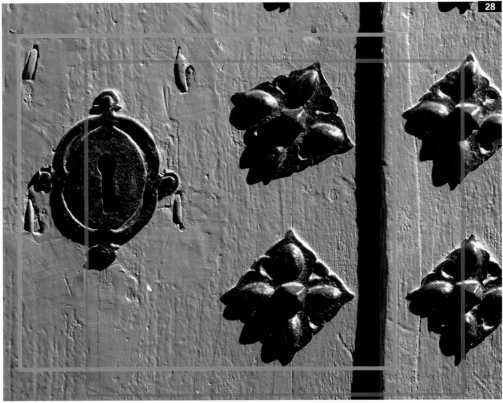

27 **Electronic viewfinder**
This illustration shows a typical EVF with picture information and exposure metering displayed around the edges. This example also shows how the centre portion of the image can be enlarged for more accurate focusing.

28 **Parallax error**
Rangefinder-style digital cameras suffer from parallax error, as the viewing lens sees a different part of the subject from the taking lens. This is shown, in this close-up of a door, by the coloured rectangles: the green line surrounds what the user sees through the optical finder but the red line shows what the camera will actually record. This difference must be taken into account when working within 1 m (3 ft) of the subject.

advantage is that they don't deplete battery power).

Because the optical viewfinders of many compact digital cameras show a slightly different view of the scene than that actually seen by the taking lens, the viewfinder is generally constructed to show more of the scene than the picture will ultimately contain. Printed lines or corners are usually supplied in the viewfinder to give the user an indication of what the picture will actually include. Often there are two sets of lines, one for distant views (such as landscapes) and one for closer subjects (such as head-and-shoulder portraits), to correct for the problem known as parallax error. Parallax is the difference in picture content caused by the viewing lens being in a slightly different place to the taking lens. For an easy example of this, close your left eye and, looking straight ahead, be aware of what you can see (your nose will block the view from the left). Now, without moving your head, open the left eye and close the right eye. Note the difference in what you can see. This is parallax at work.

Q29 | What is a preview monitor?

A preview monitor is a small LCD screen, usually located on the back of a digital camera. It is used either for viewing the scene to be photographed before a picture is taken, or for viewing the picture afterwards to check for possible mistakes.

Since the LCD is usually of quite low resolution, it is not possible to determine if the picture has the desired sharpness (most pictures look sharp when they are displayed very small). Therefore, many cameras provide a zoom facility so you can zoom in to view a section of the picture at full size to check critical sharpness.

Many cameras allow the preview monitor to be used instead of the viewfinder to frame the picture before exposure, and many users seem to have adopted this method. The downside of this is that the camera must be held away from the face to take the shot, with the resultant increased risk of camera shake.

29 **Preview monitor**
This view of the back of a compact digital camera shows the typical position of the preview monitor. Preview monitors are not accurate enough for critical image assessment, since even the angle from which you view the monitor will greatly alter the displayed image.

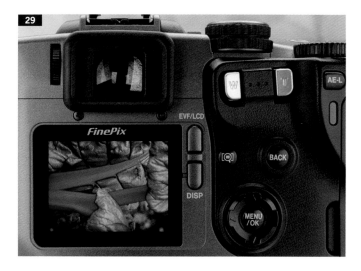

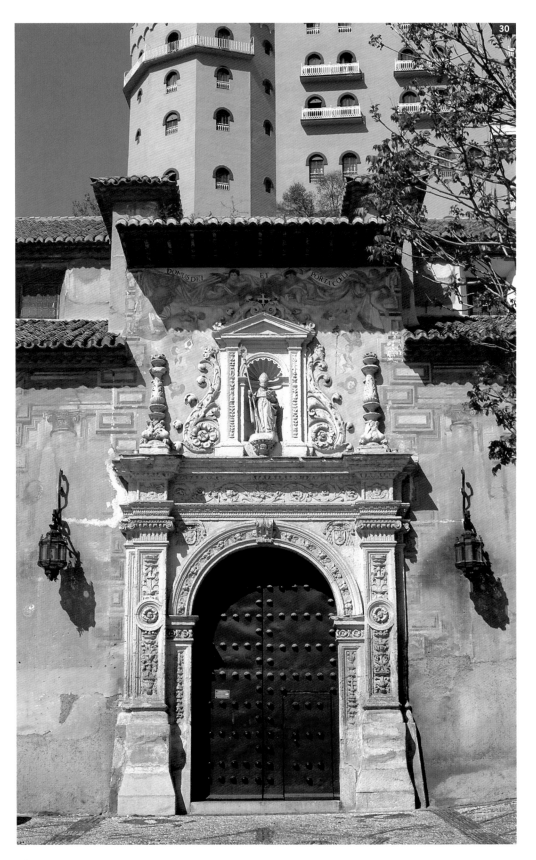

30 Church door

This view of an old church with a new hotel looming above it was taken with a wide-angle lens. This lens was needed to include enough of the subject from the chosen viewpoint.

30a Enlarged section

This picture shows just the area above the old door, and was obtained by cropping the original shot. This image now looks as if it was shot with a telephoto lens.

30b Using a telephoto lens

This is another picture of the area of wall above the door, but this time it was taken using a telephoto lens from the same camera position as the wide-angle shot. Note the much improved quality of this version. Also note that the perspective, which is controlled only by the position of the camera and not by the lens used, is the same in both versions of the close-up.

The preview monitor is also often used for displaying the camera's menu system and user-controllable options such as ISO settings, image quality (i.e. compression settings) and so on.

Q30 | What is lens focal length?

All lenses are designed to focus light at a specific distance from the lens. Most of us will have had experience of this as children when using a toy magnifying glass to focus the rays of the sun to burn paper. The distance (of the lens from the paper) at which the sun's rays become a point (and burn the paper!) is known as the focal distance or focal length of the lens.

In general, the focal length of a lens determines how much of a subject the lens will show in a picture. The longer the focal length of the lens, the less of the subject it will show in the picture. Conversely, shorter focal lengths are used to include more of the subject in the picture. We use the terms 'wide-angle' for a lens with a short focal length and 'telephoto' for a lens with a longer focal length. Telephoto lenses allow you to isolate areas of a scene or record distant subjects. Wide-angle lenses are used to include large areas of a scene (such as grand landscapes) or to create distortion for dramatic effect.

The focal length of a lens is normally marked on the lens barrel and is specified in millimetres. For example, a lens marked 24 mm is a wide-angle lens, whereas one marked 300 mm is a telephoto lens. Lens focal lengths up to about 35 mm are wide-angle, from 40–55 mm are 'normal' (because they see about the same as the human eye), and above 75 mm are telephoto.

The vast majority of digital cameras have a zoom lens, which is a special type of lens that has a variable focal length. By moving the glass elements in the lens (usually by rotating the lens barrel), different focal lengths can be set. This makes the zoom lens very versatile, because it provides infinite adjustment between the focal length limits of the lens and avoids the user having to carry several different lenses. Zoom lenses are marked with two numbers rather than one, such as 24–85 mm or 70–210 mm: these represent the lowest and highest focal lengths the lens provides.

You should be aware that zoom lenses rarely provide the same image quality as a lens with a fixed focal length. For example, the picture quality produced by a 135 mm telephoto will be superior to that of a 70–210 mm zoom lens set at 135 mm. Also, the bigger the range of a zoom lens, the harder it is for the makers to retain image quality. Thus, it is better to have three zoom lenses, each covering a small range, than one lens covering the widest range of focal lengths.

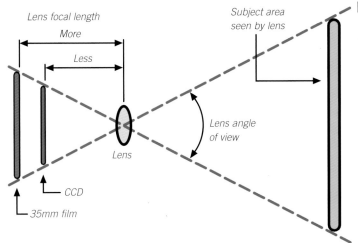

Lens focal length

More

Less

Lens angle
of view

Subject area
seen by lens

Lens

CCD

35mm film

*This illustration shows that the
smaller CCD of a digital camera
needs to be closer to the lens, and
have a shorter focal length, to
image the same subject area as a
normal 35mm camera lens.*

Q31 | What is 'equivalent' focal length?

Due to the traditional popularity and wide range of cameras and
lenses available for the 35 mm film size (135 format), many people
are familiar with relating the focal length of lenses to film size and
picture content. With the introduction of digital cameras, which use
a CCD (charge-coupled device) in place of film, the traditional way of
classifying lenses in terms of the relationship between lens focal
length and film size became more complicated. The CCDs found in
most digital cameras are somewhat smaller in size than the image
area of 35 mm film, which means that the traditional focal lengths
of 35 mm lenses are not accurate when applied to digital cameras
(even though we think of digital cameras as being 35 mm format).
This is all related to what is known as the angle of view of the lens.

Let's look at an example to clarify the situation. On a 35 mm film
camera, a 50 mm focal length lens is considered 'normal' because a
picture taken with it will contain a similar amount of the subject to
that seen by the human eye. However, if you use a digital camera
with a CCD smaller than 35 mm film, it needs a lens of shorter focal
length to record the same area of the scene. This is why digital
camera lenses always seem to have much shorter focal lengths than
would be expected for 35 mm. For example, the Fujifilm S602 Zoom
camera specifies its zoom lens as FL = 7.8–46.8 mm (the equivalent
of 35–210 mm on a 35 mm camera).

This explains why the digital camera specifications refer to
'equivalent' focal lengths; they are relating the digital camera's lens
focal lengths to the 'equivalent' 35 mm film camera lenses.

Storing images

Q32 | What are memory cards?

A memory card is the storage medium, used in a digital camera, on which the pictures you take are saved. Memory cards are removed from the camera to have prints made at a photo store, or to transfer the pictures to a computer, or to insert a new memory card when the current one is full.

'Memory card' is a generic term for storage in a digital camera. Some other names are Compact Flash, Smart Media, and proprietary brand names such as xD Picture Cards. Memory cards are solid-state devices (that is, they have no moving parts), so they are very fast, reliable and robust in use. They are available in a variety of storage capacities, specified in bytes (e.g. 512 MB, 1 gigabyte). The larger the storage capacity of a memory card, the greater is the number of pictures you can store on it.

Once you have taken your pictures, they are stored on the memory card. You can now transfer them to a computer, either via a cable connected to the camera or by removing the card from the camera and inserting it directly into a memory card reader connected to (or built into) the computer. Once a memory card is connected to the computer it is treated by the system as a remote disk drive and can be read from, or written to, by the computer.

32 Camera memory card
As shown in this picture of a digital camera, the memory card is simply slotted into the appropriate place in the camera. It is important to purchase the correct memory card for your camera, as there are various types.

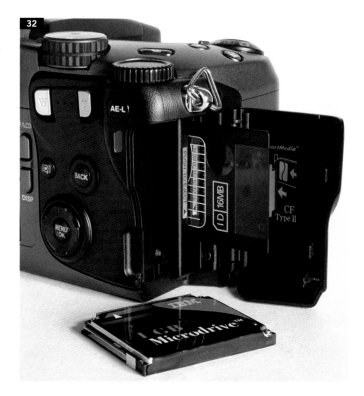

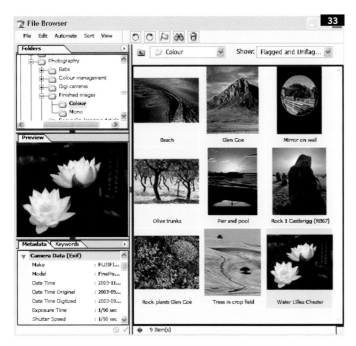

33 Image-viewing software

Once the pictures are stored, either on the camera's memory card or transferred to more permanent storage on a computer, they can be examined using image-viewing software. Image-editing software, such as Photoshop, is equipped with media browsers that allow you to choose the image to open or perform other routine file management tasks.

Q33 | Where are image files stored?

A digital camera captures the scenes and subjects you photograph via its CCD, an electronic device that creates a stream of electrical signals. These signals are processed by the camera's built-in software to create the image you see on the preview monitor of the camera. Depending on the camera settings, the image will now be either in the camera's internal memory or will already have been saved to the installed memory card.

If the picture is still in the camera's memory it is vital that you save it to the memory card before using the camera again, otherwise it will be lost when you take the next picture. If the camera is set to save the picture automatically after processing, the image will already be safe on the memory card. In either case, once the picture is saved it resides on the camera's memory card until you decide to delete it or move it to a computer.

Once you transfer the image files from the camera to a computer, the files will usually be stored on the computer's hard disk. This can be in a folder of your choosing or a folder that is created automatically by the camera when the images are transferred. Although, for example, the Windows XP operating system automatically creates a folder called My Pictures, it is a good idea to create a more organized structure of folders on the computer's hard disk for your image files. This will make it easier to locate particular pictures and form the basis of a cataloguing system.

Because they need to store a lot of information, image files are large. If you take a lot of pictures, you will need to relieve the overload on your hard disk by using external media such as DVDs.

Taking pictures

34 **Cactus – slow film speed**

Low ISO settings produce the best quality and many cameras are optimized for a digital film speed of ISO 200. The low ISO settings are ideal for subjects with fine detail, as in this picture of a cactus, or those in bright light conditions. Since the CCD is being used to its optimum, the quality is at its highest.

34a **Night lights**

In this night scene I set the ISO to 1600, the maximum available, and supplemented the ambient lighting with the camera's built-in flash. This allowed me to use a reasonable aperture for depth of field and hand-hold the camera. For added atmosphere I have purposely darkened the edges of the picture. This picture is noticeably grainier than the cactus image.

Q34 | What is digital film speed?

In film-based photography, a wide range of different film speeds are available to cope with different lighting levels or particular subjects. Film speed is used to indicate how much light a film needs to record an image. The higher the film speed (i.e. the faster the film), the lower the light levels it can be used in. For example, indoor sports activities or night scenes may require a very fast film to obtain adequate results, whereas a studio still life or outdoor scenes in bright sunshine may benefit from the qualities provided by slow film.

To provide this flexibility in digital cameras, it was necessary for the manufacturers to incorporate a simulated film speed system. For digital cameras it is better to think in terms of light sensitivity rather than film speed, although the term 'film speed' will no doubt be used for quite some time to come. The sensitivity to light of a digital camera's CCD can be varied either by changing the electrical gain (or amplification) of the CCD, or by using more of the photodiodes of the CCD to generate each pixel of the image. One major advantage of digital film speed over traditional film speed is that the required speed can be set for each individual picture. This allows you not only to take photographs under different light conditions, but also to obtain the exact camera shutter and aperture values you need for a particular subject. For example, if you are hand-holding the camera and the light meter indicates a shutter speed of 1/125 sec at an aperture of f/8, but you feel the subject would benefit from greater depth of field, you can simply increase the ISO speed setting until the meter indicates the desired f/number. Remember that the shutter speed cannot always be changed when holding the camera because of the risk of camera shake.

Owing to the methods used to provide a digital film speed system, high film speed settings inevitably reduce image quality and this should be considered when deciding which film speed to use.

Q35 | What does 'ISO' mean?

'ISO' is the acronym for 'International Standards Organization', the official body that controls how film speed is defined and specified, throughout the world, for traditional photography. The ISO speed system is a linear arithmetical scale starting at 1 and doubling in value for each doubling of a film's sensitivity to light. For example, an ISO 400 film has four times the light sensitivity of an ISO 100 film and can therefore be used in situations with lower light levels or when subject movement needs to be controlled, as in sport.

To make digital cameras easier for traditional photographers to understand and use, this ISO system has been adopted to represent

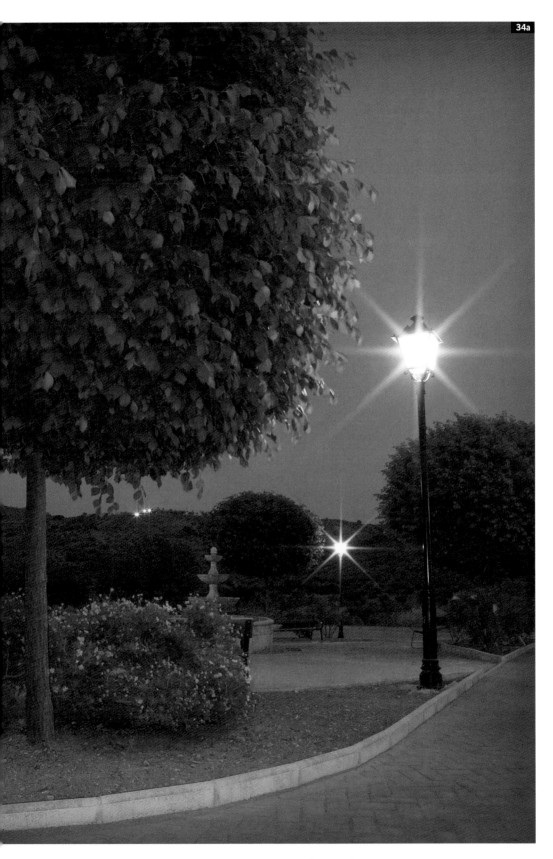

34a

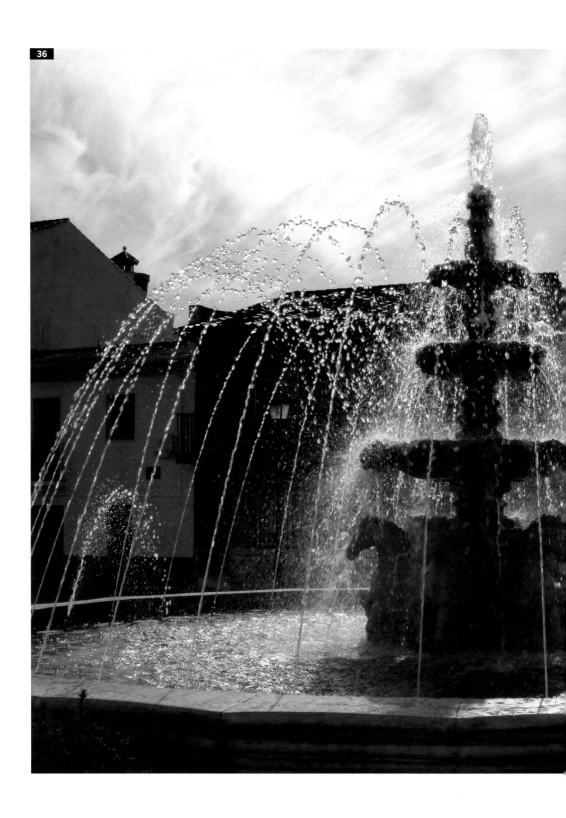

36

38 Increased depth of field

The aperture is used to control the amount of the subject, from the camera to the horizon, that is acceptably sharp in the picture. In this picture of trees with blossom, I wanted everything to be sharp so I used a small aperture of f/16 with a wide-angle lens.

38a Reduced depth of field

Reducing the depth of field by opening the aperture allows you to emphasize a subject by making the background out of focus while retaining sharpness in the main subject. This is the technique used for this close-up of a thistle. Since the thistle is quite complex it benefits from a simplified background. Note that the background is sufficiently recognizable to establish the environment for the thistle.

aperture scale. This is a logarithmic scale based on the square root of 2, with each step changing by a factor of 1.4142 (the root of 2). The scale starts at 1.

The lens aperture is used in conjunction with the shutter speed to control the amount of exposure for each subject, i.e. the total quantity of light reaching the CCD of the camera. The total exposure controls how light or dark the picture will be.

Lens apertures are actually fractions of the focal length of the lens and so are expressed as f/numbers, such as f/1, f/2.8 or f/16. Thus, f/11 on a 150 mm lens allows proportionally the same amount of light through as f/11 on a 28 mm lens, even though the actual size of the hole is different in each case. The f/numbers are also commonly referred to as f/stops, or simply stops. Note that since f/numbers are fractions, the bigger the number, the smaller the hole. For example, f/22 is a smaller aperture than f/8. So when we say 'choose a smaller aperture' we mean a bigger number.

Like shutter speeds, f/numbers also have a creative role to play because they control depth of field.

Q38 | What is depth of field?

The aperture controls the amount of a scene that is rendered sharp in a picture. As the aperture gets smaller, so more of the subject will be in sharp focus. Thus, an aperture set to f/22 will produce more sharpness in the subject than if it is set to f/8. The amount of sharpness in the subject, controlled by the aperture, is called the depth of field.

Depth of field is a powerful creative tool and is used to place more or less emphasis on parts of a subject. For example, you can reduce the distracting effect of a cluttered background in a portrait by selecting an aperture that produces just enough depth of field to keep the person sharp but allows the background detail to blur into a pleasing soft backdrop of colour or tone. Conversely, in a landscape scene with interesting foreground and background details, a large depth of field, obtained with a wide-angle lens and a small aperture of say f/16 or f/22, will render all aspects of the scene sharp.

With digital image-editing software, the general concept of depth of field can be extended to apply out-of-focus effects to localized areas of the picture to create more interesting results of this type. Unfortunately, it is much easier to create out-of-focus effects than to make a blurred image appear sharper.

Q39 | When do I use the flash?

Most digital cameras have a built-in electronic flash, which is used when the amount of light on the subject is too low for a normal exposure. On most cameras the automatic exposure facility will alert the user when flash may be required. In some cases, the camera will use the flash without giving the user a choice, based on the

assumption that the camera is being hand-held and long exposure times are not practical. For the vast majority of 'happy snaps' this would be the case but for more controlled results, automatic use of the flash may not be desirable.

As a rule of thumb, if the camera exposure system indicates that a shutter speed of less than 1/125 sec is needed, and the camera is being held in the hand, you should use flash to avoid blurring the picture through camera shake.

The main problem with on-camera flash is that it produces very flat lighting and usually uneven exposure throughout the scene (objects near the camera receive far more light than those farther away). Typical examples of this are the many party pictures we see where our friends' faces are very bright and pale, with nice red eyes, while the background is almost black. Some cameras try to help counter this problem by having an exposure mode setting that combines the flash light with the available light in the scene to produce a more balanced lighting and exposure.

Q40 | How do I use fill-in flash?

The technique of fill-in flash is used creatively to help control the effect of high-contrast lighting. High-contrast lighting typically produces dark, hard-edged shadows containing little useful detail. A silhouette is an extreme example of such a high-contrast subject.

Since digital cameras tend to have a similar contrast range to traditional colour transparency film, you will often be faced with the problem of the subject contrast exceeding that of the camera's range. One easy solution is to use the camera's built-in flash to add light to the scene, which helps to 'fill in' any dark shadows. This technique is best used in situations where the shadows to be lightened are fairly close to the camera, and therefore within the range of the flash.

The method is as follows. Set the camera so that it exposes the sunlit parts of the scene correctly – they should be bright but with detail. You may need to experiment using the preview monitor to get the best settings. Once this is done you need to create a balance between this daylight exposure and the flash exposure, so the shadows are lightened sufficiently.

The contribution of the flash to the picture exposure is controlled solely by the value of the f/number. To determine the effect of the flash and sunlight together, leave the exposure set for the daylight and take a picture with the flash switched on. Check the result on the camera's preview screen. If the shadows still look too dark, open the aperture by one stop and increase the shutter speed by one value (this keeps the sunlight the same but increases the flash contribution) and take the shot again. Conversely, if the shadows look too light, close the aperture by one stop and use the next slowest shutter speed. Check the result again and continue in this way until you are happy with the picture.

39 **Horse statue – no flash**
Although most people think of flash as being for use indoors in dimly lit rooms, it is actually far more versatile than that. This example demonstrates that without the camera flash, the main subject of this picture, the statue, is too dark.

39a **Horse statue – with flash**
By allowing the flash to fire, I have given the statue enough light to record correctly and it now looks much better. Since the effective distance of the small camera flash is quite limited, the buildings in the background were totally unaffected by the flash light.

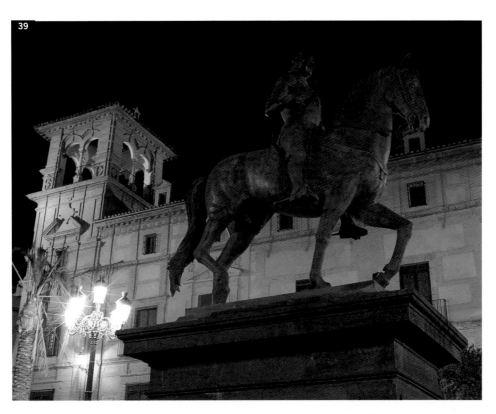

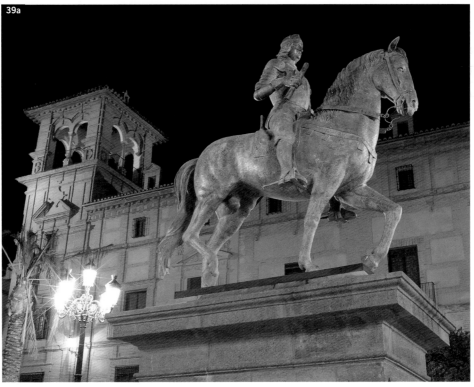

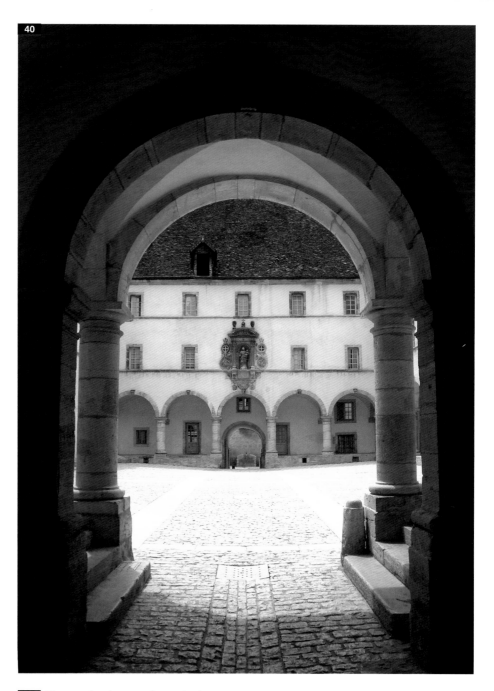

40 **Plaza courtyard – excessive contrast**
*This view into a courtyard is typical of a subject with
excessive contrast. I adjusted the exposure to give
the best detail throughout the subject but the arch is
too dark and the courtyard too light. The solution is
to use fill-in flash.*

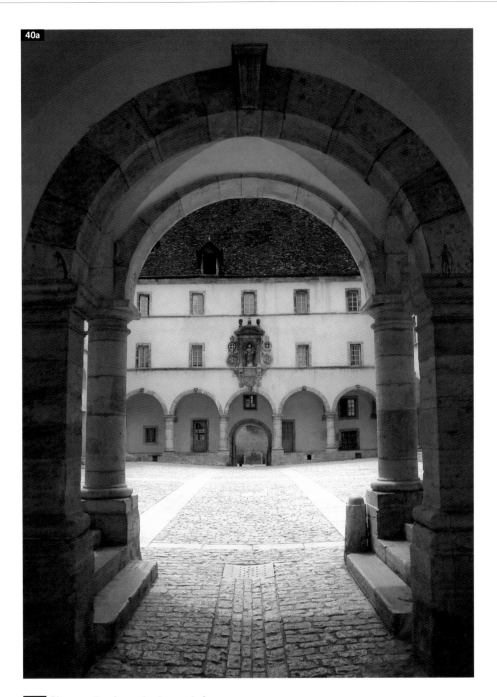

40a **Plaza courtyard – contrast corrected**
*I set the exposure for the light area of the
courtyard to obtain the desired level of detail on
the ground. This exposure made the arch even
darker than the previous version. By firing the
camera flash during the exposure I was able to
add light to the archway without affecting the
distant courtyard. The optimum balance was
achieved by adjusting the aperture (to control
the flash) while changing the shutter speed to
keep the courtyard exposure constant.*

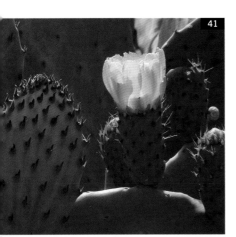

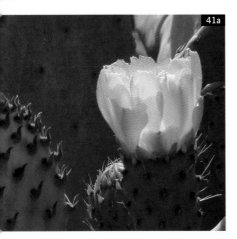

41 Cactus flower

The minimum focus distance of a lens increases with focal length unless the lens has a macro facility. Thus, for this picture of a cactus flower, using the camera's zoom lens on maximum focal length meant I was around 50 cm (20 in) from the plant. This was the limit using the optical zoom but it allowed me to use the maximum quality of the camera (6 MB).

41a Cactus close-up

Since digital zooming requires the camera to interpolate existing pixels, it is necessary to switch to a lower quality setting on the camera. In this case, the maximum file size was 1 MB, but it allowed me to zoom even closer to the flower for this tighter composition. However, this picture cannot be enlarged beyond about 10 cm (4 in).

Q41 | What does digital zoom do?

Digital camera technology has allowed the development of some useful camera-based features to provide the user with more options when taking pictures than was possible with a traditional camera. One such feature is the incorporation of digital zoom in digital compact cameras.

All zoom lenses have a range of focal lengths from the minimum to the maximum. This is known as the optical range of the zoom and is specified on the lens in the form 24–100 mm, 70–210 mm and so on. On a traditional film camera this zoom range would be the limit, but with a digital camera it is possible to extend the maximum focal length of the zoom artificially by enlarging the recorded picture within the camera software. This technique is known as digital zoom.

The downside of digital zoom is that the software uses a method called interpolation, which creates new pixels from existing ones. The result is always a slight reduction in the picture quality, which gets worse as more digital zoom is applied. However, this quality loss may only be noticeable if larger prints are produced from the digital file.

Digital zoom is a neat way of providing a greater apparent range for the camera without resorting to more complex optics in the lens.

Q42 | How do I control sharpness in-camera?

There are several factors, controlled by the user, that have an impact on picture sharpness. On a practical level, unwanted camera shake, lens quality and focusing, and subject movement cause the most problems. Two other factors influencing the perception of image sharpness are depth of field and digital sharpening.

Camera shake causes double images in the picture and can be avoided by holding the camera correctly and using a suitably fast shutter speed. Better still, you can use some form of tripod or flat surface to hold the camera rock-steady. When holding a camera, try to press it gently against your face and hold your elbows against the sides of your body. Breathe out just before taking the picture to steady your body. When hand-holding a camera try never to use a shutter speed slower than 1/125 sec. For long lenses, the shutter speed figure should not be less than the focal length of the lens.

All cameras provide auto-focus and most of the time this will be accurate. However, there are occasions when the auto-focus system cannot cope or when manual focusing would be more accurate, such as for dark scenes or moving subjects.

When dealing with subject movement, you must decide how sharp you want the main subject to be, controlling it by the shutter speed. Fast speeds freeze movement while slow speeds allow the subject to blur, which may allow you to retain the impression of movement.

Digital sharpening is done after the picture is taken, either by the camera's software or by image-editing software (or a combination

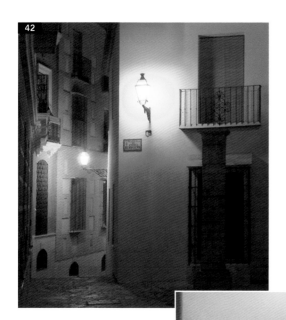

42 Camera shake

At slow shutter speeds, hand-holding a camera will produce camera shake – a blurring of the image due to camera movement. This has occurred in this picture of a street scene at night. Although at a small size the image may not look too bad, examination of the enlarged section shows the extent of the blurring.

42a & b In-camera sharpening

Many cameras allow the picture to be sharpened using USM (the Unsharp Mask filter) after exposure in the camera. USM can make the image look sharper and is usually used as the last step before printing although, as here, it can be used in the camera. The first image shown here has no sharpening, while the second has the maximum USM permitted by the camera.

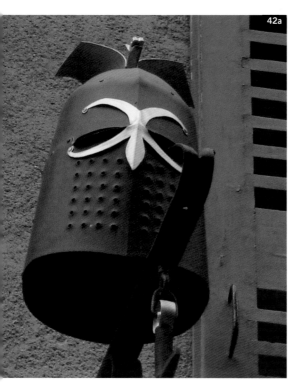

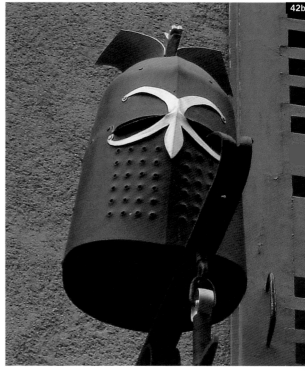

43 Slow shutter speed

In this dramatic picture of water flowing over a dam, I used a fish-eye lens pointing into the sun. To obtain some blurring in the water but to retain the textural quality, I used a shutter speed of 1/30 sec. The choice of shutter speed is a personal decision; in this picture a faster speed would have made the water too static while a slower speed would have resulted in much of the dramatic wave patterns being lost.

43a Romantic landscape

This classic view of sunflowers in a Mediterranean landscape has been romanticized by placing a diffusion filter in front of the lens. These filters are available in different strengths to permit a range of effects.

43

43a

of the two). All digital images need some sharpening because they are inherently soft when captured by the CCD. Since image-editing programs usually have advanced tools for sharpening an image, it is recommended that little or no sharpening takes place in the camera.

Q43 | How do I create blur in-camera?

Using blur and softness (diffusion) in a picture is a visually creative technique used to convey the feeling of movement in a static picture and/or to create romantic or ethereal images. The main ways in which you can introduce blur or diffusion into a picture at the camera stage are: camera movement during exposure, slow shutter speeds to allow subject movement, reducing the depth of field, and using a soft-focus filter on the front of the lens.

For subject or camera movement, it is worth experimenting on different subjects with various shutter speeds to gain experience of what does and does not work.

For romantic portraits of people or to create ethereal landscapes, try using a soft-focus filter on the lens. This creates diffusion in the image, which has the effect of making light areas of the subject glow. One nice aspect of diffusion is that the stronger the diffuser, the softer the image becomes, which allows you to control the effect. This technique is used extensively by wedding photographers. A cheap alternative to a filter is to use clear plastic food wrap. Just stretch a piece over the front of the lens for an instant romantic look.

Q44 | What is a digital movie?

Many still digital cameras provide the facility to record a sequence of still images which are then combined into a digital movie by the camera's software. Although not as good as a camcorder, this feature allows you to record important moments or create short movies for use on your web pages. Some cameras are also equipped with a microphone to allow you to combine sound with a movie sequence.

The more sophisticated cameras allow the user to specify the picture dimensions of the movie in order to provide different levels of quality. Needless to say, the memory card in the camera needs plenty of space to store digital movie files. The amount of space available on the memory card will generally dictate the running time of a movie.

Digital movies are usually stored in the PC-compatible AVI format or in motion JPEG format. Sound files are usually in the WAV format. Both the movies and sound can be played back either through a computer or direct from the camera to a television screen (using a suitable cable).

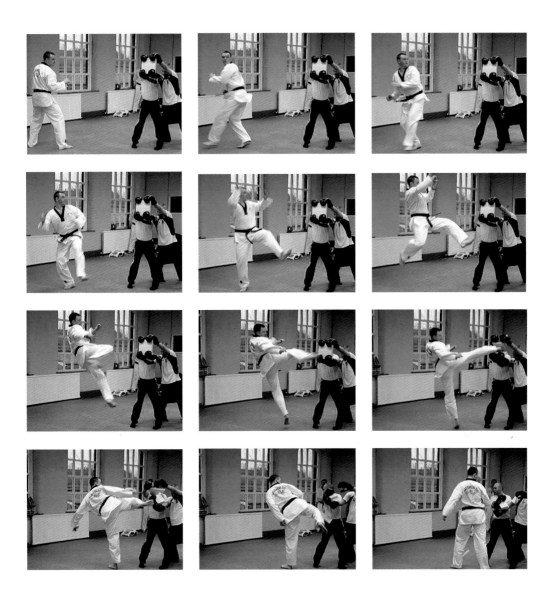

44 Taekwondo kick

This sequence of images (screen grabs) has been taken from a digital movie recording a taekwondo kick being performed, for use on a website. As shown here, a digital movie is simply a series of still images, of relatively low quality, that when played as a rapid sequence blend together into a single movie. When the images are played as a movie, the low quality is not noticeable.

Downloading

45 FireWire socket

This is the IEEE 1394 FireWire socket on a laptop computer. Note that this is a four-pin socket.

Q45 | How do I connect my camera to a computer?

Most digital cameras can be connected directly to a computer using a suitable cable. There are two main interfaces (an interface is simply a system that allows two machines to communicate) that are used for the transfer of digital information between a computer and an attached device such as a camera. The fastest interface is IEEE 1394, better known as FireWire®, while the other is USB (universal serial bus), which at the time of writing is in version 2.0. FireWire devices are either four- or six-pin devices, so be sure to obtain the correct cable for your system. FireWire is a high-speed system ideal for handling large image files.

To connect the camera and computer using a USB cable you simply plug one end into the camera and the other into a spare USB socket on the computer. Since USB is a 'hot wire' system, it is not necessary to switch the computer off before connecting the cable. When you switch the camera on, the computer system will automatically recognize it and open any dedicated image viewer installed on the computer. When disconnecting the camera from the computer you must make certain you follow the correct procedure, as specified in the instruction manual for your camera, to avoid damage to the camera.

If the computer is equipped with a memory card reader you do not need to connect the camera itself: it is easier to remove the memory card from the camera and insert it into the appropriate slot on the computer. The computer will recognize the card as an additional disk storage device, allowing you to use it like any other disk drive.

Q46 | How do I transfer my pictures to a computer?

Once a digital camera is connected to a computer, or the memory card is slotted into the card reader connected to (or built into) the computer, the computer operating system treats the memory card just like any other disk drive. This allows you to use the normal file management tools (such as drag and drop) to transfer the image files to your hard disk in a folder of your choice.

Alternatively, many digital cameras are supplied with dedicated software that you can install on your computer to allow the viewing and transfer of pictures to the hard disk. This software often opens automatically once the system recognizes the camera and displays the pictures currently stored on the camera's memory card. It is usually possible to conduct basic file management tasks with the software supplied, such as saving or deleting pictures, creating a print order using DPOF (digital drint ordering format) and converting between file formats.

45a

45a USB 2 connection

This picture shows a digital camera being connected to a laptop computer using the USB 2 cable supplied with the camera. As this is a hot wire system, the cable can be connected while the computer is switched on. When the camera is turned on, the computer's OS will detect it automatically.

46 Memory card slots

An easier method of moving your images to a computer is simply to plug the memory card into a card slot. An adaptor may be required, as shown here, for a microdrive. Once plugged in, the computer's OS will automatically recognize the card as another disk drive.

46a Image-management software

Most cameras are provided with image-management software that allows you to move your pictures from the memory card to the computer's hard drive. The example shown here is the Fujifilm FinePixViewer program, which starts automatically when a Fuji digital camera is detected to be connected to the computer.

46

46a

Chapter 3 | **Scanning and printing**

There are two main ways to obtain a digital image file: use a digital camera or scan photographic film or prints. This section will first examine questions related to scanning. Scanning is a very important part of the digital image process for people who have previously used traditional film-based cameras. These people, whether just holiday snappers or serious photographers, may have many images stored away as either film or prints which now need to be digitized for use with a computer and image-manipulation software. Most of the relevant scanning issues will be covered on the following pages.

The rest of this section will look at questions related to printing digital image files. Since the usual outcome of digital imaging is the creation of a nice print, many of the important questions relating to this subject are answered in this section. Digital image printing, especially at home with an inkjet printer, can be a complex business and we can only provide selected topics of interest in a book of this kind.

Spanish hats *Home scanners and printers have advanced to the stage where they are now capable of successfully handling even the most extreme tonal and colour ranges. This picture of Spanish felt hats contains both rich saturated colour and a wide tonal range, and would previously have produced unsatisfactory results when printed.*

Scanning

Q47 | What are menus for?

All programs that utilize a GUI (graphical user interface) have their commands organized into what is known as the menu system. The menu system is a logical structure that displays a program's commands in lists using different levels of drop-down menus. Related commands in each menu are organized into groups, separated by lines, for easy access. The top-level menu for each group of commands is displayed on a menu bar found at the top of the program's main window. The menu bar will contain names such as File, Edit, Print, Window, and so on, to indicate the tasks the commands within that menu relate to.

Clicking with the mouse on one of these menu names opens the first sub-menu level. Each sub-menu may also contain further sub-menus to allow multiple-level commands to be accommodated. Lower levels of sub-menus are indicated by a right-facing black arrow next to a command name and are opened when the mouse is over the name. As well as the basic menus of File, Edit, Window and Help, each program will also have menus containing the specific commands relevant to the tasks of that program.

Many commands can also be accessed using 'hot keys', which can be quicker than using the menu system. The hot key combination assigned to a specific command is shown on the menu. The hot keys can usually be modified if desired.

Q48 | What is a scanner?

A scanner is an electronic device that can digitize analog information to create a digital file from hard copy originals. Scanners can digitize either flat copy, such as photographic prints and written documents, or photographic film (and other transparent materials). With suitable software a scanner can also become an OCR (optical character recognition) device for recognizing words printed on paper. Using OCR to process printed documents removes the need to re-type a document if you wish to copy it into the computer.

The scanner uses a light source and special sensors that are moved across the item being scanned. As these travel, they take thousands of individual samples of information about tone and colour. These samples are then processed and saved to create a digital file.

For digital imaging, a scanner is used to digitize either photographic print or film originals to produce a digital image file. Scanners are connected directly to a computer and controlled by special scanning software. Good scanning software allows the user to select which parameters and features of the scanner are needed in

47 Sample menus
This screen grab shows a typical menu structure, starting with the first level, called Image, which drops down the list of available commands. A command with a right-facing arrowhead to the right has a sub-menu, so clicking on the Adjustments command has opened another level of commands.

Paper

47 **How a scanner works**
This conceptual illustration shows how the scanner light is directed to the sensors via a series of mirrors when scanning flat documents or photographs.

order to obtain an optimum scan of the original. For example, the brightness, contrast and colour of a photograph can be modified, and the pixel size and resolution of the digital file can be specified. These modifications to the scan are previewed in the scanning software prior to making the final scan.

Once an item has been scanned it can be opened in an image-editing program for additional enhancement and printing.

Q49 | How is scanner quality defined?

The quality of a scanner is expressed by two pieces of information, the optical resolution and the maximum density range. For example, a scanner may be specified as having an optical resolution of 4800 dpi with a maximum density range of 3.5 (written as Dr 3.5).

What this means is that the scanning head can create 4800 samples per linear inch of the original and can sample densities between 0 and 3.5 density units (photographic prints and film use density values to specify the tonal values). Generally, the higher the optical resolution and density values, the better the scanner.

Scanner manufacturers usually provide two numbers to specify the resolution, e.g. 4800 x 9600 dpi. The first number refers to the number of digital samples taken per inch: this is the true optical resolution. The second number refers to the number of discrete steps made by the stepping motor that moves the scanning head. This is not the resolution of the scanner!

50 Hebden Bridge

This image was scanned full size at 300 dpi, producing a printed image size of 4.10 x 3.66 in (104 x 92 mm). However, the file doesn't contain enough information to enlarge the picture later.

50a Low-resolution section

This 1.6 in (40 mm) square section of the original was scanned at only 102 dpi, resulting in a low-resolution image. This resolution would be suitable for Internet web pages only. The accompanying screen grab shows the scanner settings used.

50b Medium-resolution section

This section was scanned at the same size as the low-res version, but this time the scanning resolution was 410 dpi. This has produced an image suitable for printing at full size. Note the increase in detail from the low-res version. The screen grab shows the settings – note the increase in file size.

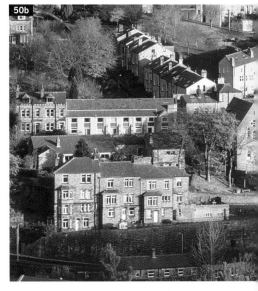

50c High-resolution section

This section was scanned at the same size as the others but at the maximum optical resolution of the scanner, i.e. 1640 dpi. This image has the best detail and can be enlarged without loss of quality. Note the file size on the associated screen grab.

50d Resampled section

This section has been resampled down in Photoshop from the high-resolution version to produce a resolution of 410 dpi. The quality is indistinguishable from the version actually scanned at 410 dpi. Down-sampling produces good quality whereas sampling up reduces quality very quickly.

Q50 | What is the best resolution to use when scanning?

There are different opinions regarding the best resolution to use when making a scan. One school of thought is that you should determine the scan resolution based on the intended use of the image. In other words, if you want a picture for a website that needs to occupy a quarter of the screen when the monitor resolution is 1024 x 768, the original needs to be scanned at a pixel size of 256 x 192 with a resolution of no more than 96 dpi (monitor resolution is no higher than 96 dpi). However, this particular scan would not be any use for making, say, an A4 print because it is simply too small in terms of both pixels and resolution. For an A4 print the original would need to be scanned again with settings suitable to produce a 25 MB file size.

The second school of thought recommends scanning all film originals at the highest optical resolution the scanner can produce, with the image dimensions the same as the original. This produces the biggest file size with the best resolution. Later, when you need to use the image, the file can be resampled down to the desired size. In this way you scan the original only once, then reuse the file. The downside of this method is that you need lots of storage capacity to cope with the resulting large file sizes. For example, if you were scanning a 35 mm colour negative on a 4800 dpi scanner, you would

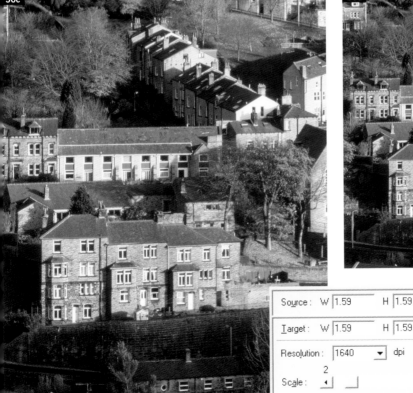

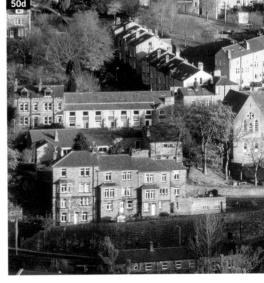

| Source : | W | 1.59 | H | 1.59 | | inches | ▼ |

| Target : | W | 1.59 | H | 1.59 | 🔒 | inches |

| Resolution : | 1640 | ▼ | dpi | | 19.45 MB |

| | 2 | | | 780 |

| Scale : | ◄ | __| | ► | 100 | % |

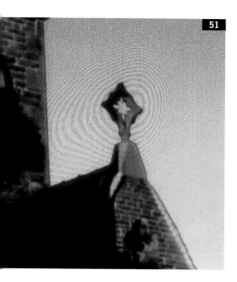

51

Newton's rings

This enlarged section of a film scan shows quite clearly the disastrous effect of Newton's rings on the smooth tones of the image. In areas of detail the fault is less obvious, but it is still a real problem that is best avoided.

set the resolution to 4800 and the zoom factor to 100 per cent (or the dimensions to match the chosen cropped area of the negative). This would produce the highest quality scan the device was capable of and the biggest optimum file size (with no interpolation). The file size for a full 35 mm frame would be 88.3 MB (for an 8-bit image). This file could then be used to make a 24 x 16 in (609 x 406 mm) print or resampled in an image-editing program for use on a website.

Q51 | What are Newton's rings?

Newton's rings form when minute particles of moisture become trapped between the glass of the scanner and the glossy surface of the original, such as the back of a negative. The effect of Newton's rings on the final scan is seen as uneven rings of subtle colours (or tones in black and white). These rings are very difficult to remove from the scanned image.

The best solution is to prevent them forming in the first place. There are various means of avoiding this problem, the easiest of which is to prevent the film from touching the scanner glass by using a small spacer between the film and the glass. Many scanners provide plastic holders for this purpose but a thin piece of paper with a hole in it will do the job (remember the problem occurs only on one side of the film). Also, make sure the scanner glass and film are completely dry and free from grease marks prior to scanning.

Q52 | What is colour management?

Colour management is the process of control implemented by digital image users to ensure that the colour values produced by different pieces of equipment are consistent with each other.

For example, when a scanner or digital camera produces a digital file, the various colours in the file will be allocated specific colour values. When that digital file is displayed on a monitor or printed on a colour printer, the colour values in the file will be interpreted by the new device in a way specific to that device. If this interpretation of the colour values is different from that of the original scanner or camera – and it usually is – the colours produced by the new device will be different to those of the original source.

To produce consistent colour when transferring images from one device to another, it is essential to use a colour management system (CMS). A CMS calibrates each device in the imaging chain – scanner, monitor, printer and camera – so that the interpretation of the colour values by each device is consistent. In this way, when you view a digital file on a computer monitor and then make a print, the print will be a very close match to the monitor image (accepting the limitations of printing inks compared to monitor screens). A CMS uses colour profiles for each device in order to control the colour translations from one device to another.

Q53 | What is a colour profile?

Colour profiles are basically tables of colour values, which are used by imaging devices to translate the colour values of one device into those of another in such a way that the colours in the image remain visually constant.

As an abstract example, if a digital camera assigns the number 25 to a particular colour but your colour monitor produces that same colour only when it reads the number 36, then the colour profile assigned to the monitor needs to alter the colour value from 25 to 36 before displaying it on the monitor. Similarly, the printer may print that exact colour only when it receives the number 28, therefore the printer colour profile needs to translate the monitor colour value of 36 to 28 for the print colour to match the monitor colour. This translation process is applied to all the colour values in the digital file as they pass from one device to another. (This is a simple explanation of a complex process.)

For a colour management system to work correctly it is necessary to have each piece of equipment colour-profiled using special profiling software to produce the correct table of translation values. The calibrated colour profile is then assigned to the device to incorporate it into the CMS workflow.

53 **Sample profile data**
This is a sample of the data stored in a colour profile. The numbers are used to interpret the colour values of one device into those of another to maintain consistency.

53

SAMPLE_ID	RGB_R	RGB_G	RGB_B	XYZ_X	XYZ_Y	XYZ_Z
ORIGINATOR	"Profiler"					
DESCRIPTOR	"My monitor"					
MANUFACTURER	"Example profile"					
NUMBER_OF_SETS	15"					
NUMBER_OF_FIELDS	"7"					
BEGIN_DATA_FORMAT						
SAMPLE_ID RGB_R		RGB_G	RGB_B	XYZ_X	XYZ_Y	XYZ_Z
END_DATA_FORMAT						
BEGIN_DATA						
CBL	0	0	255	18.0573	7.22046	95.0775
CGR	0	255	0	35.7513	71.521	11.9141
CRD	255	0	0	41.2415	21.2616	1.93481
DMIN	255	255	255	95.05	100.003	108.929
GS1	250	250	250	90.8661	95.6024	104.132
GS2	238	238	238	81.2683	85.5042	93.1305
GS3	221	221	221	68.7256	72.3083	78.7628
GS4	205	205	205	58.0292	61.0535	66.4978
GS5	190	190	190	48.9441	51.4954	56.0883
GS6	175	175	175	40.7471	42.868	46.6949
GS7	160	160	160	33.4106	35.1532	38.2904
GS8	146	146	146	27.3193	28.7445	31.308
GS9	133	133	133	22.2931	23.4589	25.5463
GS10	119	119	119	17.5354	18.4479	20.0928
DMAX	0	0	0	0	0	0
END_DAT						

Q54 | How do I calibrate my monitor?

Monitor calibration should be considered the first important job you need to do before starting a digital image enhancement session. Calibration is used to remove any colour cast the monitor may have and optimize the brightness and contrast controls so that a full range of tones between black and white can be seen. It is important that you calibrate the monitor under the same room lighting conditions that there will be when you are using it. You should also allow a CRT monitor to warm up for 30 minutes before calibration, or use a TFT screen that doesn't need to warm up.

Professional studios use sophisticated, dedicated hardware and software to calibrate their monitors closely, but a good job can be done with the Adobe Gamma utility supplied with Adobe Photoshop.

If you don't have access to a calibration utility it is still possible to make adjustments using the monitor's own adjustment options. On most monitors you can adjust brightness, contrast and colour balance. Start by creating a test target in your image software, by making a new file at 72 dpi in greyscale mode, big enough to fill your screen. Next, make a tone scale from black to white against a neutral mid-grey tone. Set the contrast of your monitor to maximum and adjust the brightness setting of the monitor until you can just see all the tones of your scale. Finally, adjust the colour controls until the neutral background tone has no obvious colour cast. Save the monitor settings with a unique name such as 'My Monitor'. It is also worthwhile saving the calibration image for future use.

Q55 | How do I calibrate my scanner?

To calibrate a scanner it is useful to have a purpose-made colour original such as an IT8 target (available in reflective/print and transparency versions). Alternatively, you can download a sample file from the Internet (www.digitaldog.net is a great source) which you then print on photographic quality, glossy inkjet paper. Start by

54 **Adobe Gamma utility**
This is the interface for the Adobe Gamma monitor calibration utility, which is installed as part of Adobe Photoshop. The first step in using the utility is to set the contrast of your monitor to 100 per cent. Now you can choose either to use the wizard, which will step you through each stage of the calibration, or use this dialog box to make changes.

54a **Adjusting brightness**
To calibrate monitor brightness, adjust the brightness control until black and grey patches in the Brightness and Contrast panel almost merge together. Notice how the dialog box has darkened in response to the monitor brightness being reduced.

54b **Adjusting Gamma**
The Gamma adjustment controls the colour and mid-tones of the display. Squint your eyes as you look at the screen and move the slider under the sample grey patch until the centre merges visually with the outer edges.

54c & d **Adjusting colour**
For fine control over the colour of the monitor display, you can adjust each primary colour individually. Just to illustrate how the changes work, the result of making extreme changes to Red and Green is also shown here.

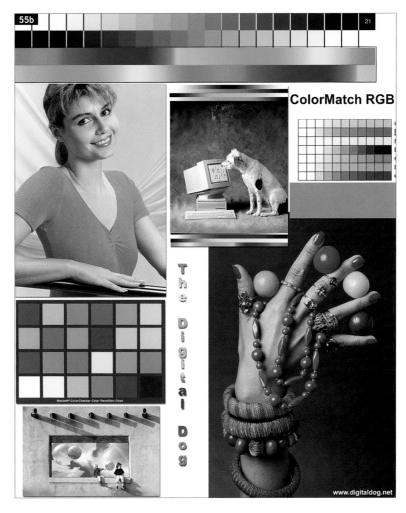

55 | | | 1 | | | 2 | | | 3 | | | 4 | | | 5 | | | 6 | | | 7 | | | 8
1 |2 |3 |4 |5 |6 |7 |8 |9 |10 |11 |12 |13 |14 |15 |16 |17 |18 |19
Centimeters

KODAK Color Control Patches ©Eastman Kodak Company, 1977 〔Kodak〕

Blue | Cyan | Green | Yellow | Red | Magenta | White | Brown | Black

55a | | | 1 | | | 2 | | | 3 | | | 4 | | | 5 | | | 6 | | | 7 | | | 8
1 |2 |3 |4 |5 |6 |7 |8 |9 |10 |11 |12 |13 |14 |15 |16 |17 |18 |19
Centimeters

KODAK Color Control Patches ©Eastman Kodak Company, 1977 〔Kodak〕

Blue | Cyan | Green | Yellow | Red | Magenta | White | Brown | Black

55 Colour test target

Standard colour patches such as those from Kodak, shown here, are used to make scanner calibration easier. (A more complex version is the IT8 target, which contains many more colours.) This is a straight scan of the target. Notice the slight colour cast in the grey areas, and that the contrast is slightly lower than optimum.

55a Amended scan

By assessing the raw scan, adjustments can be made to improve it. This scan had slight adjustments to the colour and contrast made in the scanner software. Once you are happy with the settings, save them for future use.

55b Ready-made test target

Test targets like this one from www.digitaldog.net can be printed and then scanned to use as your standard target. Since this target contains far more information than the simple Kodak colour patches it is easier to assess the results.

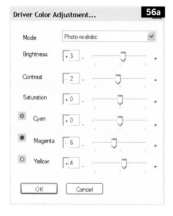

Look for the colour adjustment settings in your Printer Driver dialog, similar to this screen grab, and make sure they are set to zero for the first test print.

56a **Colour settings adjusted**
Assess each test print and move the colour adjustment sliders to correct the colour cast on the print. In this dialog I have made minor adjustments to remove a green/blue colour cast and slightly lighten the print. A new test print will now be required before refining the settings further.

scanning the target with the scanning software fully on auto to check how good a job it does. Then scan manually, adjusting the preview until it looks as close to the original as possible.

On your calibrated monitor, examine the scans in your image software (they often look different from the scanner previews) and assess for colour and tonal range. This will show you any colour bias the scanner may have. Amend the scanner settings until you get a good match with the original, and then save the settings in the scanner software and use them as standard for future scans.

Q56 | How do I calibrate my printer?

The best way to calibrate a printer is to have a colour profile produced specifically for your printer. Unfortunately, a colour profile is specific to one printer, one type of ink, and one type of print paper. This means a new profile is needed each time you change one of these items. For most hobby users, who love to experiment with different media, this is not practical.

As an alternative, you can produce your own profiles by saving the print settings in the printer driver software. If the printer driver software allows you to adjust colour and tone (contrast) values, these can be tweaked using test prints to obtain a print that closely matches the monitor image. Once the best settings have been found, they should be saved to a file for future use. The next time you are using the same brands of ink and paper you can simply load in the saved settings for those media before making the print.

Start with all the colour settings in the Printer Driver dialog at zero and make a small test print on the desired paper. It is best to use a colour test target that contains a wide range of colour and tone patches. Compare the print with the original screen image and assess the print for colour casts and tonal range. Make any adjustments using the Printer Driver Colour Adjustment settings and then make a new print. Continue in this way until you have the best print possible and then save the settings with a relevant name (e.g. EpsonMatt1440 for Epson matt paper at 1440 dpi). Next time you want to print on this paper, at this resolution, simply load these saved settings into the printer driver software, load the printer with paper, and print.

Q57 | How do I scan film and prints?

To scan photographic film (e.g. colour negatives) you need either a dedicated film scanner or a flatbed scanner with a transparency adaptor. To scan prints or other flat originals you require only a flatbed scanner.

The first step is to thoroughly clean both the scanner (especially the glass platen on flatbed types) and the item to be scanned, to remove any dust and grease marks. This produces the cleanest scan and will reduce the time spent later cleaning up the scanned image.

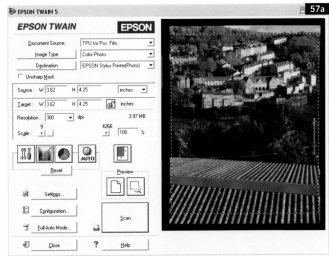

57 Preparing to scan film

Many flatbed scanners can be equipped with a transparency adaptor, as shown here. The film is placed in special film holders and everything is cleaned to avoid dust and other unwanted marks marring the scan.

57a Scanning film

The scanning software may be launched from within your image program using the TWAIN interface (usually with the File/Import command) or independently as a stand-alone program. The first step is to launch the scanning software and generate a preview in the scanning window. Use the Crop tool to indicate the area of the preview you want to scan, before doing any adjustments.

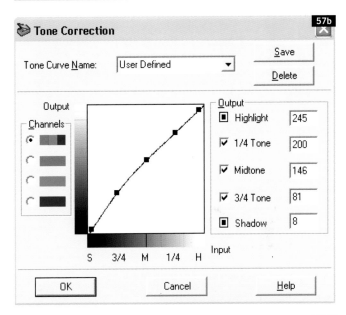

57b Curves adjustment

Use the Curves dialog to adjust the colour and tonal values. Curves provide the most versatility although they take a little longer to learn.

57c Ready to scan

Once the preview window shows the image just as you want it, check that the size and resolution are correct and click on the Scan button to make the final scan.

58 Mobile movement

The final image, shown here, was made by compositing a scan of the original phone with the distorted background image to convey the mobility of cellular phones.

58a Distortion during scanning

To obtain the distorted background image for this picture of a cellular phone, I placed the phone on the flatbed scanner and, after setting the resolution to 300 dpi, moved it several times during the scan. Several attempts were required before I was happy with the final effect.

Align the original squarely on the glass platen before scanning, to avoid having to rotate the image in your image-editing program. Film scanners provide film and slide holders that align film correctly for scanning.

Launch the scanning software and specify the type, size and resolution of scan you require, then create a preview of the scan. Before making any assessment of the preview, use the Crop tool to specify the area of the image you want and refresh the preview. Assess the preview for contrast, tone and colour and use the various tools to make any adjustments, then make the final scan.

Open the scanned file in your image-editing program, zoom to 100 per cent and check the whole image carefully for minor defects. Use the editing tools to remove these defects and save the file. You now have a clean scan ready for creative editing.

Q58 | How do I scan other objects?

One of the interesting and fun aspects of a flatbed scanner is the ability to scan objects other than flat documents. The method of scanning solid objects is the same as for film and prints. When scanning solid objects, it is not possible to close the lid of the scanner, so to produce a neutral background for the object, use a piece of white or black cloth to cover the scanner during scanning.

The main aspects to be aware of when scanning solid objects are that the lighting on the object will be from the front and the plane of sharpness will be where the object touches the glass. This will produce a gradual fall-off in sharpness on parts of the object farther away from the glass platen. The scanning of solid objects is often used as an alternative to photography for producing a digital collage or photomontage. This is limited only by your imagination.

To scan the object, set the resolution to 300 dpi and crop to the object in the preview window of the scanning software. Set the zoom factor to 100 per cent if you want a life-size image, or change the size as desired. Check that the resolution is still at least 300 dpi to obtain good quality in the scan.

An interesting technique, when scanning solid objects, is to create distortion effects. Since the scanner uses a moving head to create the scan, if an object is moved in the direction of the head as the scan progresses, it will stretch the image of the object. Conversely, if the object is moved in the opposite direction to the scanning head, the image will be squashed.

Printing

Q59 | What is a digital photographic print?

A digital photographic print is made from a digital image file in a special processing machine that prints the image on to traditional photographic print materials. It is usually sharper and has brighter colours than a traditional print from a film negative, because it is created using laser light from the digital original, which avoids many of the quality issues associated with traditional methods.

Of course, it is essential that the digital file you provide for printing is of adequate size for the print size you require. If this is not the case, the picture will be of lower quality than expected. Traditional film negatives do not have this problem. Many cheap digital cameras, although great for happy snaps, produce a file size that is only suitable for postcard-sized prints, whereas even the cheapest film-based camera can produce a negative that is suitable for enlargement to at least A4 size.

59 Digital photo prints
A selection of digital prints made by a professional mini-lab service. Prints like this can be made straight from your digital camera, or after image processing on a computer.

Q60 | How do professional mini-labs work?

All photo stores and photo mini-labs now use digital printing machines, whether they are processing digital images or film. When you supply them with a traditional film it is first processed in the

59

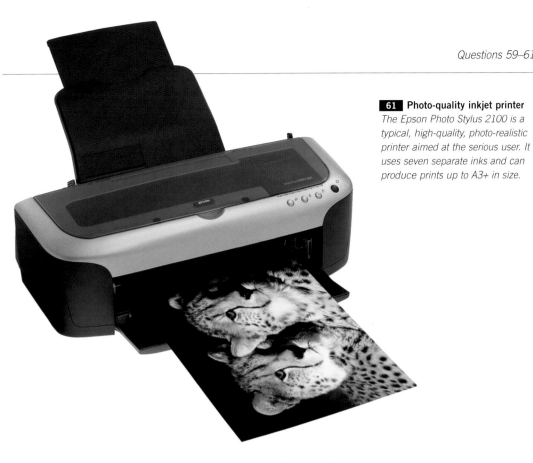

61 **Photo-quality inkjet printer**
The Epson Photo Stylus 2100 is a typical, high-quality, photo-realistic printer aimed at the serious user. It uses seven separate inks and can produce prints up to A3+ in size.

usual way and then each image is scanned prior to digital printing. Since the film has already been scanned, many mini-labs offer the extra service of putting the images on to CD for you.

Mini-labs can also produce digital prints direct from the various camera memory cards. The card is simply plugged into a remote workstation attached to a printing machine. The workstation has a monitor and command system that shows previews of the images stored on the memory card, and allows the user to select various options before prints are made.

Digital printing also makes it much easier for a photo store to offer the photographer additional options such as cropping, enlarging, and colour balance correction. This is almost as good as having the traditional custom hand-printing service provided by pro-labs for professional photographers.

Q61 | What is a photo-quality printer?

The home digital image-maker now has a vast range of affordable printers to choose from for making prints. However, although there are many budget inkjet printers on offer, not all of these are suitable for printing photo-quality prints. A photo-quality printer is optimized for producing smoother tones and colours, and excellent detail. The manufacturers usually make it clear which of their printers are designed for photo-quality printing.

Generally, photo printers contain six or more separate ink colours and have a printing resolution of around 2880 dpi (although 1440 dpi is more than adequate on printers with only four separate ink colours,

e.g. for black and white printing). Photo-quality printers are available from all the major manufacturers, such as Epson, Canon, Hewlett Packard and Lexmark.

Q62 | What does 'inkjet' mean?

'Inkjet' is the term applied to printers that use liquid inks that are sprayed in minute droplets on to the surface of the printing medium. The number and size of the droplets determines the quality of the final print. In the world of fine art, where semantics are often more important than the artwork, high-quality inkjet printing has been given the name *giclée* (which is French for 'squirt') to try to differentiate it from normal inkjet printing, although they are in fact the same thing.

Q63 | How does an inkjet printer produce an image?

An inkjet printer sprays minute droplets of each ink colour on to one small space on the printing medium. The colours are applied in different proportions of the three secondary colours – Yellow, Magenta, and Cyan – which combine to generate the various colours of the image. Black is also used, to add contrast and depth to the tones of the image.

The print head deposits the ink by travelling forwards and backwards across the print medium. Each pass of the print head lays down many droplets of ink, thus gradually building up the image. It is essential that the print head is working properly since any clogging of the minute nozzles will result in banding and white tramlines across the print.

The print medium, which may be paper, linen or canvas, is specially coated to accept the inks from the printer. The coating helps to reduce ink spread (which can reduce sharpness and detail), speeds the drying of the inks, and improves the colours in the picture. Although it is possible to print on non-coated media, this should only be done for your own creative purposes and not for general high-quality photo-realistic prints.

63 Inkjet printer head
This conceptual diagram shows how the ink is applied to paper using a transducer to make the fine droplets required. As electrical current flows through the transducer it causes a minute droplet of ink to be sprayed from the nozzle.

64 Inkjet printing papers
This picture shows a small selection of the types of inkjet media available. Working from the back, the samples are of glossy paper through to matt and textured papers. The front print is on inkjet canvas. One point to note is the variations in tone and colour of the samples. This has an effect on the final print colours.

Q64 | Why are there so many printing papers?

One of the great aspects of the growth in digital imaging is that there are now a great many manufacturers producing goods for the expanding market. One area where this is particularly noticeable is in the manufacture of materials for inkjet printing. It seems that everyone associated with paper manufacture is producing a range of inkjet paper.

Although this vast selection of inkjet papers may seem intimidating to the newcomer it is actually good news, since the more choice you are offered, the more likely you are to find just the right paper for your personal taste. There is nothing worse than having only two or three options and not liking any of them.

To make choice easier, several manufacturers produce sampler packs of their products. These usually contain two sheets of each of the more popular paper types, such as glossy and matt surfaces, and one sheet each of the more unusual items in the range, such as inkjet canvas or linen. This is a great way of experimenting with different media without breaking the bank, since good-quality inkjet paper is certainly not cheap.

65 | Do I need specialist inks when printing pictures?

The printing inks and papers produced by the printer manufacturers are designed to work with the designated printer in the most efficient way. Therefore, for the majority of users, good results can be

65 Specialist inks
Ink cartridges compatible with the major brands of printers are available from independent ink manufacturers. This cartridge contains the Lyson Fotonic inks for use with an Epson printer. These inks are also available in bulk using a continuous ink system (CIS).

obtained by using proprietary ink cartridges and paper without having to look further afield. However, since printer manufacturers are not specialist inkmakers, and because serious photographers and artists are always looking for perfection in their work, several independent ink manufacturers have developed their own ink formulations, papers and software (known as RIPs or raster image processors) to try to improve on the marque products.

The independent dye- and pigment-based inks are claimed to produce a wider colour gamut (the range of colours possible in a colour system), greater stability and improved light-fastness compared to the marque brands. The manufacturers claim that these improvements will produce superior prints with smoother tonal ranges and a lifespan of at least 75 years. So, although you do not need specialist inks for normal printing, if you want to obtain the very best quality for your work it would be worth investigating the products of the independent makers.

The specialist inks fall into two groups: dye-based and pigment-based media. Dye-based inks are the most common because they are easier to produce, and one of the notable independent manufacturers is Lyson UK. Dye inks are usually capable of producing brighter colours with a wider gamut, hence prints tend to have more punch. The downside of dye inks is that they are usually more prone to fading in daylight so the projected print life is less than that of the pigment-based alternative. Pigment-based inks have colour pigment (like traditional coloured printing inks) suspended in the medium. Colour pigments are longer-lasting than colour dyes, making the print lifespan greater. However, pigment inks have a smaller gamut and tend to lack the bright saturation of their dye equivalents. A positive aspect of pigment inks is that they can be printed on to almost any medium, whether coated or not, making them great for experimentation and creative printing. They are favoured by serious black and white photographers who demand top-quality digital prints comparable to traditional photographic silver-based prints. Notable names are MIS, Cone, and Permajet.

One of the interesting, but frustrating, aspects of both dye and pigment inks is that they usually behave differently on different papers. The effect of this is that although you may produce superb results with one ink and paper combination, if you change to a different type or brand of paper, the results may not be as expected. Each combination of ink and paper has unique qualities that can be discovered only by experimenting with various makes.

Q66 | What does 'dye-sub' mean?

'Dye-sub' is short for 'dye-sublimation', which is a specific method of making prints from digital files. Instead of spraying ink on to paper as is the case with inkjet printers, dye-sub uses special paper and ink sheets. In the printing process the ink is transferred from one to the

67, 67a & b Printing with resampling
The three images shown here were printed from the same file at a printer resolution of 2880 dpi. For each print, the file was resampled down in Photoshop to reduce the image resolution but keep the size constant. The resolutions are 300, 240 and 192 dpi. The images printed here are scanned from the actual prints so some loss of quality in reproduction is inevitable. On viewing the prints carefully, there was virtually no detectable difference between the 300 dpi and 240 dpi images. The 192 dpi image showed more perceptible edge definition (due to less smoothness in the tonal values) but a reduction in the tonal smoothness. However, for non-critical use the quality was definitely acceptable.

67c&d Printing without resampling
When you wish to make different-sized prints from the same file it is necessary to change the image resolution without resampling the file. The two images here show the result of doing this with the sample picture. The first was changed to 240 dpi while the second was at 192 dpi. As can be seen, this changed the image size. The 240 dpi print was almost identical in quality to the original 300 dpi sample but the 192 dpi print has started to show a noticeable reduction in tonal smoothness. However, the edge sharpness appears to be better. My conclusion is that, for this printer (an Epson 1290), the lowest excellent quality resolution is 240 dpi, but for work prints I could print as low as 200 dpi.

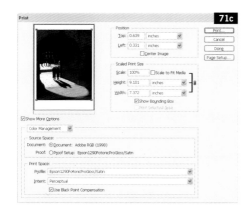

71c Print Preview dialog

The Print Preview dialog allows you to specify how the image will be positioned on the page, whether to print a border around the image, and other extra features. If you are using a colour management system, you can specify the profile to be used with the printer. In this example I have specified a profile optimized for use with Lyson Pro Glossy paper.

71d Select Printer dialog

Clicking the Print button in the previous dialog opens the Print dialog, where you can choose which printer you want to use. From here, the various features of the printer can be accessed by clicking on the Properties button.

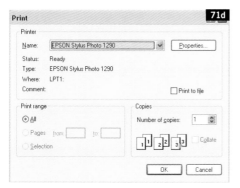

71e Paper Size dialog

When the printer Properties dialog opens, the first step is to check that the paper size is correctly specified. Then click the Main tab to access the print quality features.

71f Print Quality dialog

The Main tab from the previous dialog opens the main control centre where you specify all the parameters for the print. First, choose the type of media from the drop-down list. It is crucial to choose the right media so consult your paper instructions. The Mode area is where you tell the printer how to handle colour. Clicking on the Advanced button gains access to more parameters for fine-tuning the print quality.

71g Advanced print settings

The Advanced dialog allows you to specify the printer resolution, the media type and the colour management options. This is also where you can fine-tune the colour settings to create your own printer profiles.

71h Photo Enhance

Epson print drivers have the facility to use Photo Enhance, which allows you to intuitively control various aspects of the print. The small preview window shows the effect of any changes you make.

to use the correct paper setting to achieve a good print. Use the various Advanced dialog parameters to set the quality and colour options as desired to produce the first test print.

When you are ready, click the OK button in the Print dialog box and wait for the print to appear. Once printed, leave the print for several minutes to allow the ink to dry properly before assessing the result for colour, brightness and contrast. You can adjust the quality options for the next print if necessary to improve the result.

Q72 | How do I make prints of different sizes?

The easiest way to produce prints of different sizes from a digital file is to change the resolution of the image without resampling it. In Photoshop, this is done in the Image Size dialog box. Resampling

72 Image Size dialog
The Image Size dialog box shown here is for an image of 6.3 x 4.6 in (160 x 116mm) at a resolution of 300 dpi. This is a standard printing resolution. Note that the resampling box is left blank so that when the resolution changes, the file size remains constant.

72a Print Preview
This screen grab shows the Print Preview dialog where you can see the size of the image on the chosen paper. Note the image does not fill the paper when set at 300 dpi (see previous screen grab).

72b Changing resolution
Changing the resolution to 200 dpi in the Image Size dialog will make the image print at a larger size than before. In this example the image will now print to a size of 9.49 x 7 in (241 x 177 mm).

72c Reviewing Print Preview
Checking the Print Preview dialog we now see that the image will almost fill the paper being used. Using this method retains the original image file size but allows different print sizes. The limit is how low the resolution can be while still producing good quality (usually around 240 dpi).

changes the file size of the image, either by adding or removing data, and this changes the final quality of the digital picture. This is not desirable when you are simply making different-sized prints. The best solution is to switch off resampling and adjust the resolution until the dimensions of the image are as desired. For example, if you change a file of 8 x 10 in (203 x 177 mm) at 300 dpi so that the resolution is 250 dpi (without resampling) the image will now print at a size of 9.6 x 12 in (243 x 304 mm). If the resolution of the image is then changed to 480 dpi, the print size will be 5 x 6.25 in (127 x 158 mm). In this way different print sizes can be made without changing the data in the original file.

If you need to make a print that is greater than the file size can manage using this method you will need to resample the file. This is done with the resampling box checked in the Image Size dialog.

Chapter 4 | **Creative image-making**

This section answers many important questions about digital image manipulation. There are a lot of creative techniques and much important information in the following pages, so it is worth spending time getting to grips with these topics.

Some of the topics covered will be easy to understand without reference to earlier sections of the book, whereas other, more advanced issues will benefit from an understanding of the technical points previously discussed. Some of the methods described are simply included for fun, and are easy enough for a novice to try. However, others relate to more complex imaging techniques and provide a foundation for advanced digital imaging explorations. Once you have experimented with all the methods contained in this section, you should be ready to create your own digital masterpieces.

Abstract water lilly *Painters have always been able to create whatever their imaginations could conjure up. Now, at last, photographers have the same creative freedom when using digital manipulation, so why not let your creativity blossom too?*

Digital image manipulation

Q73 | How do I make an image darker or lighter?

The easiest way to make an image darker or lighter is to use the Levels command and adjust the middle slider to change the gamma (the middle tone range) of the image. This is preferable to using the Brightness/Contrast command, because the Levels command maintains the tonal differences better.

A more advanced method, which provides finer control, is to use the Curves command and adjust the shape of the curve as required. Curves allow you to darken or lighten selected parts of the tonal scale (e.g. just the darkest shadows).

Q74 | How do I correct image contrast?

Overall image contrast can be corrected using the Levels command. If the image has weak shadows (i.e. the shadows look too light), then use the black slider to darken them. If the shadows are fine but the lighter tones are not light enough, then use the white slider to correct them. If both the shadows and light tones are incorrect, use a combination of both sliders to correct the image.

For more advanced contrast control, use the Curves command to adjust the tonal values. Many images benefit from an S-shaped curve to improve contrast.

73 Tower and trees
Taking this picture in the late afternoon, against the light, produced rather dark shadow areas. This is easily corrected using the Curves command to adjust the tonal balance.

73a Corrected shadow tones
The corrected version of the tower picture now shows much better detail in the shaded areas of the subject, producing a better feeling of light.

73b Curves dialog
The adjustment to the Curves, to correct the shadows of the tower picture, can be seen in this screen grab of the Curves dialog. By click-dragging on the curve you pull it to adjust the tonal values. Clicking once on the curve produces a fixed point, which helps isolate portions of the curve.

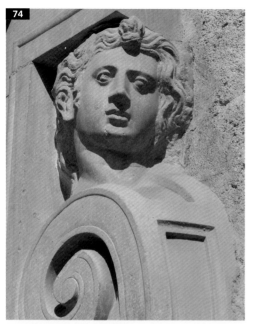

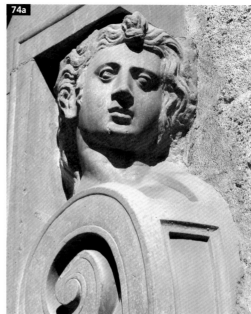

74 Stone face

This picture of a carved face, although made in bright sunshine, is lacking in tonal contrast due to the similarity of colour and tone of the stone. This has produced a low-contrast image, which can be seen by checking the Levels command for the image (see the Levels dialog screen grab).

74a Corrected contrast

To correct the contrast using the Levels dialog, drag the triangular sliders for the black, white, and middle tones until you are happy with the result (see the Levels screen grab). Compare this version to the previous one and note how much stronger the tonal values are after correction.

74b Alternative method

For more advanced control of contrast adjustment, use the Curves command. This screen grab shows the Curves dialog with the curve adjusted to produce the same result as the Levels command used on the stone face picture.

75 **Madonna face**
*This picture of a metal Madonna
was taken indoors with available
mixed light and has a distinct colour
cast. This can be corrected using
the Colour Balance controls.*

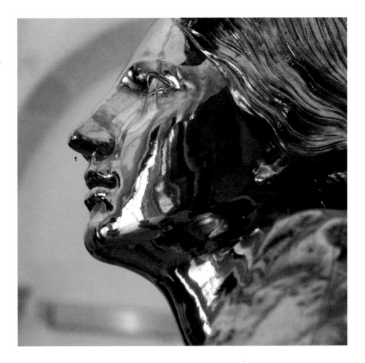

Q75 | How do I correct a colour cast?

Most image-editing programs provide a variety of ways to correct
overall colour casts. Some programs have automatic correction
commands, many have a colour balance command that allows you to
adjust the primary colours, while professional applications provide
colour correction through the Curves command.

Obviously, the easiest (but the least controllable) is to allow the
program to correct the image colour automatically. This can work
quite well for many pictures and is worth trying to save time.

Another relatively easy method is to use the Colour Balance
command or the Colour Cast Removal command. This method
generally allows you to make subtle adjustments to the different
colour channels.

The most comprehensive and versatile method is to use the Curves
command, which allows each colour channel to be adjusted using a
tone curve. This permits very precise colour adjustment in different
parts of the tonal range. You simply click and drag the line of the
graph to change its shape and hence the relevant colour content
of the image.

Q76 | How do I convert a colour image
to black and white?

The easiest way to convert a colour image to black and white is to
remove the colour using the Desaturate command. This removes the
colour component of the image leaving a range of grey tones (each

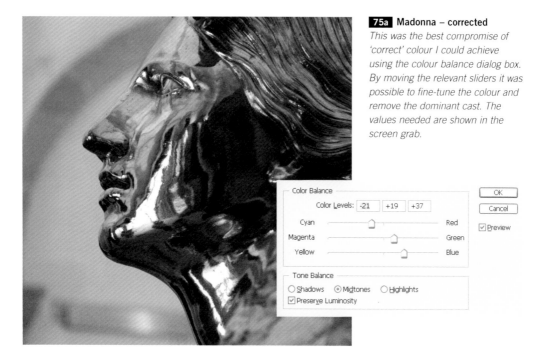

75a Madonna – corrected
This was the best compromise of 'correct' colour I could achieve using the colour balance dialog box. By moving the relevant sliders it was possible to fine-tune the colour and remove the dominant cast. The values needed are shown in the screen grab.

colour channel of the image is now identical). Unfortunately, this method rarely produces a pleasing result.

The most flexible method is to use the Channel Mixer command, which allows you to control the contribution each colour channel will make to the final conversion. In this way, you can adjust the relationship of colours to tones, in the same way that you would use colour contrast filters with black and white film. Start by examining the tonal values of each colour channel of the image and decide which is closest to your desired result. Then, when you open the Channel Mixer dialog box, you can select that colour from the drop-down list and adjust the contribution of the other two colours. Make sure you click the Monochrome box to show the previewed image in black and white, after you have chosen which colour channel to base the result on. To avoid excessive tonal distortion, try to make sure that the total percentage for the channels is around 100 per cent.

Q77 | How do I tone a mono image?

There are various ways to add colour to a black and white image. First make sure the image mode is RGB, to allow colour to be added.

The simplest toning method is to create a new layer above the image, fill it with the desired colour then change the Blending mode of this layer to Overlay. In Photoshop you can do this easily using a new fill layer. Use the opacity of the layer to adjust the strength of the colour. A more flexible method is to use a Hue/Saturation adjustment layer with the Colorize option checked. Select the colour using the

76 Poppy and grass
This picture of a red poppy against green grass would require a contrast filter if made using black and white film, as when in monochrome, the red and green would be similar in tone. With digital techniques the conversion can be made after the picture has been taken.

76a Desaturate command
This version was made using the Desaturate command, which simply removes all the colour information. The result is disappointing and is similar to the tones obtained on unfiltered black and white film.

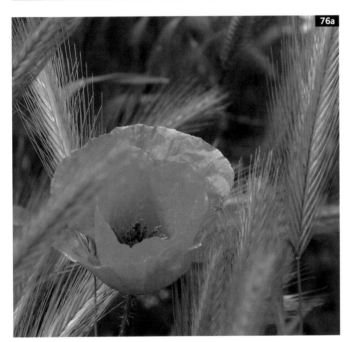

76b Channel Mixer command
Using the Channel Mixer command, it is possible to convert the colours to monochrome by using different proportions of the colour information. In this way you can control the final tonal contrast – as if you had used contrast filters with black and white film. See the Channel Mixer screen grab and note that the Monochrome box is ticked. Also, to avoid tonal distortion, try to make the three colour values in the dialog add up to 100 per cent.

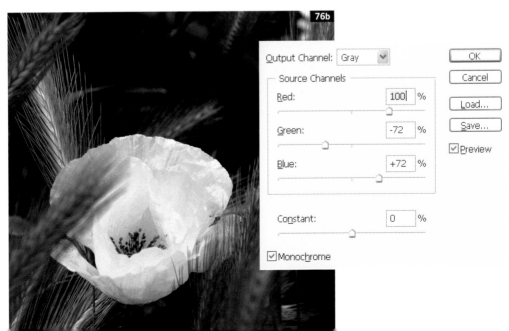

Output Channel: Gray

Source Channels
Red: 100 %
Green: -72 %
Blue: +72 %

Constant: 0 %

☑ Monochrome

OK
Cancel
Load...
Save...
☑ Preview

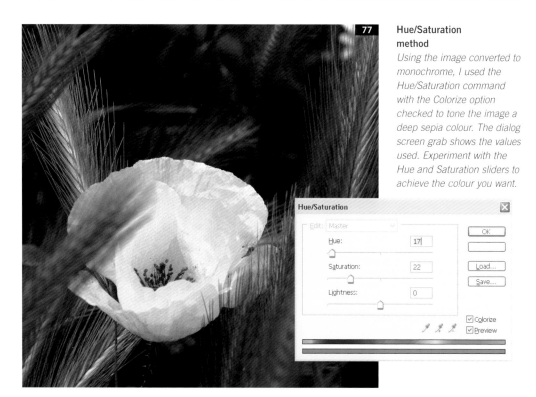

77

Hue/Saturation method

Using the image converted to monochrome, I used the Hue/Saturation command with the Colorize option checked to tone the image a deep sepia colour. The dialog screen grab shows the values used. Experiment with the Hue and Saturation sliders to achieve the colour you want.

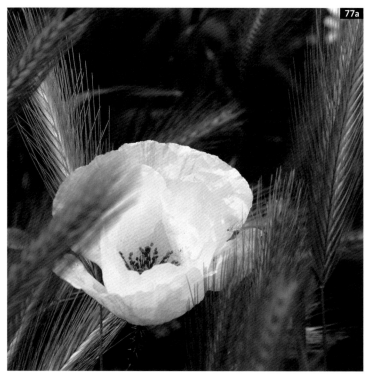

77a

Duotone method

More advanced toning is possible using the Duotone command. The image needs to be converted to Grayscale mode and then to Duotone mode to open the Duotone Options dialog box. Tritone and quadtone allow multicoloured toning effects to be achieved. This version used the tritone method to achieve the subtle difference in colours across the tonal range.

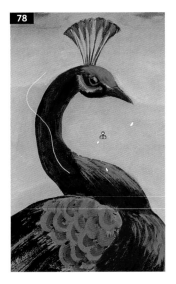

78 **Removing dust specks**

To remove dust marks with the Clone tool, ALT-click (OPTION-click on Macs) next to the mark and then 'paint' over it. Where there is little detail you need to match only colour and tonal values.

78a **Removing hairlines on detailed areas**

When a scratch or hairline runs over a detailed area, it is important that you choose the clone point very carefully so that the detail looks correct afterwards. If necessary, choose lots of different clone points in sequence to add variety to a textured area.

78b **Misalignment of cloned area**

The edge of the neck line circled in red shows what happens when you don't line up the Clone tool correctly. The cloned section from just above has been painted in slightly the wrong place. Use Undo to go back and try again. It takes some practice to become good at using the Clone tool. With more random areas of detail this is less of a problem, but wherever there are lines or definite shapes, you need to be accurate.

Hue slider and the amount to be applied using the Saturation slider.

The most expressive toning method is to use duotones, tritones or quadtones. If the picture is in RGB mode, first convert to Grayscale and then convert to Duotone. When you do this, the Duotone Options dialog opens to allow you to select the desired colour or colours and specify the distribution of the colour within the tonal range. Duotones are great for simulating the look of selenium- or gold-toned prints. Tritones and quadtones are ideal for creating multi-toned images (i.e. one colour in the high values and a different one in the low values).

Q78 | How do I use the Clone tool?

Next to the selection tools, the Clone tool is one of the most used tools in any image software. The Clone tool allows you to pick up one part of an image and paint it over another part of the image. The Clone tool is used extensively for everything from removing minor dust and scratches after scanning to removing unwanted image detail or even adding completely new detail from a different image.

To use the Clone tool, you must first indicate which area of the image you want to clone (usually by ALT-clicking the image) and then simply paint over the area you wish to change. It's just like using a Brush tool. One drawback of the Clone tool is that it can appear too obvious because you create a repeating pattern of image detail. To avoid this, make sure you constantly renew the cloned point (ALT-click) so that detail is picked up from different, but similar, areas.

Q79 | How do I remove unwanted defects?

The commonest causes of defects in a scanned image are dust and scratches in the scanner or on the original image. The two main methods of removing the defects are applying a Dust and Scratches

79 Dust and scratches

This scanned picture shows typical dust specks, a hairline and scratch lines running across the image. These all produce white blemishes in the image.

79a Dust and Scratches filter

To remove most of the defects, a Dust and Scratches filter was used. This filter usually has two settings: Pixel Amount tells the filter how many pixels to work on around the defect, and Threshold specifies the number of different colour values to use. By using these settings you can optimize the result for sharpness and defect removal. Note the reduction in sharpness of the highlights on the oranges.

79b Filtered image sharpened

This shows the filtered image after using the Unsharp Mask filter (USM) to recover some of the lost sharpness.

79c Clone tool correction

The defects in this version of the image were removed with the Clone tool. Note the difference between the highlights in this image and the Dust and Scratches filtered version.

79d Dust and Scratches filter dialog box

These are the settings used for the filter. The preview enables you to assess exactly what the filter is doing as you adjust the values.

80 Seedhead

In this close-up picture of a seedhead, I disliked the out-of-focus seedhead in the background on the right. I didn't want to remove it entirely – using the Clone tool would do this – so I opted to use the Healing Brush.

80a Seedhead – corrected

Using the Healing Brush has allowed me to tone down the background distraction without eliminating it. Since the Healing Brush blends tones and colours, it is more subtle than other similar tools.

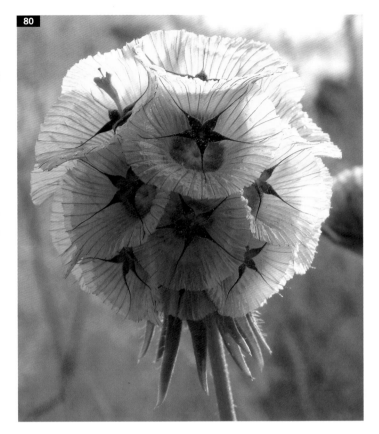

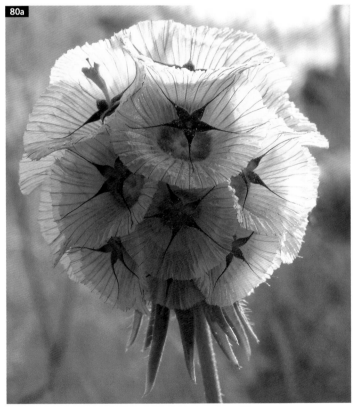

filter, which works by blurring pixels around white marks to fill them in, or using the Clone tool. The Clone tool tends to be the tool of choice because it allows greater control, but it does take more time to correct an image this way.

If there are only small dust specks or thin scratches on the image, careful use of the Dust and Scratches filter will quickly remove them. However, the downside of using this filter is that it will make the whole image less sharp, it may remove subtle highlights and it may also obscure fine detail, so be careful not to use it indiscriminately as a quick-fix solution.

Q80 | How do I use the Healing Brush?

An advanced tool in Adobe Photoshop, but one that is very easy to use, is the Healing Brush. Like the Clone tool, the Healing Brush allows you to correct imperfections in the image, making them blend into their surrounding pixels. Also like the Clone tool, the Healing Brush uses pixels sampled from an image or pattern to paint with. However, what makes the Healing Brush more advanced than the Clone tool is that it also matches the texture, shading, transparency, and lighting of the sampled pixels to the source pixels. The result is that the repaired pixels blend seamlessly into the image.

To use the Healing Brush, select it from the toolbox and choose the options you require, such as the Brush Size and Blending mode, from the Options toolbar. Point the mouse cursor at the pixels to use for the repair and ALT-click (OPTION-click on Macs) to define the starting point for the sampled pixels. Then simply drag (hold the left mouse button down while moving the mouse) the mouse cursor over the area to repair or replace.

Q81 | How do I remove 'red-eye'?

Pictures of people lit using the flash built into the camera frequently exhibit an effect called 'red-eye'. Most of us will have seen red-eye: it is the bright red spots that appear in the eyes of people photographed with flash. Red-eye is so common in family snaps that

80 Red-eye effect
Using on-camera flash when photographing faces usually results in the dreaded 'red-eye' effect. This is obvious in this snap of a baby.

80a Colour Replacement tool
Using the Colour Replacement tool, click to define the colour to replace and simply paint over the offending red-eye colour. The tool can be seen removing the colour in this close-up of the baby's eye.

80b Baby face
The final picture with the red-eye removed. The whole operation takes no more than a few minutes.

82

Creating a panorama

82, 82a & b Photographing the scene
These images show just three out of a sequence of twelve I made to produce the panorama shown below. Each image in the series should overlap the subject by 50 per cent, as shown here. Try to keep the focus and aperture constant for each image and the camera perfectly level. It also helps to make three different exposures of each image to cope with the changes in lighting levels as you pan across the scene.

82c The Panorama Factory program
I used the Panorama Factory program's wizard feature to automate the process. This screen grab shows a typical dialog in the sequence and some of the parameters that you can control.

82a

82d Selecting the image sequence
The required images are imported into the program and modified as necessary with colour adjustments, lens distortion correction and so on, before the program stitches the images together.

82e The final stages
Once the program has created the panorama, you can choose how it should be saved. One of the versatile features of the Panorama Factory program is that it allows you to save the image in VTR format to create 360° environments for games and walk-through scenes for the Internet.

82b

82f Village panorama
The final panorama was almost twice as long as this cropped version, which has a nicer shape than the original. Some minor tonal adjustment was made to the right-hand side for balance but note how the stitching process is almost perfect, showing just how good the Panorama Factory program is.

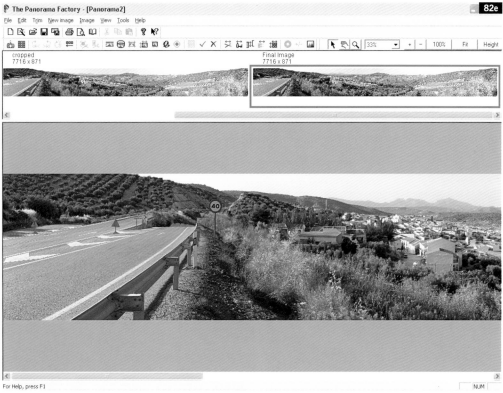

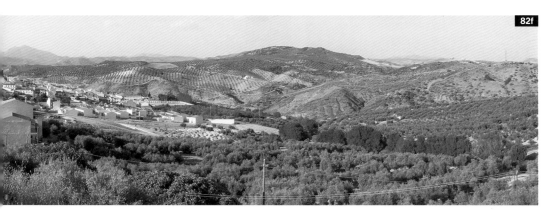

83 Running girl

I wanted to create an ethereal atmosphere for this picture of a girl running through a courtyard. The first step was to cut out the girl and place her on a new layer to avoid the filters affecting her image. The hole left in the background by removing the girl was repaired using the Clone tool.

83a Applying Motion Blur

The background was copied to two new layers for subsequent manipulation. The Motion Blur filter was applied to the lower layer with a direction of 0°. This has caused detail to be obscured and tones to darken.

many image-editing programs have a facility built in specifically to correct the problem.

In Adobe Photoshop, use the Colour Replacement tool to change the red to black (make sure black is the current colour by pressing the hot key 'D'). Choose a smaller Brush Size than the area to correct and set the tool options as follow. Mode: Colour; Sampling: Once; Limits: Discontiguous; Tolerance: 30 per cent; and with Anti-Aliased selected. Click once with the Colour Replacement tool on the red colour in the eye and paint over it. The red will be replaced by the current colour. If the tone that remains is too light, use the Burn tool with the same-sized Brush to darken it.

Q82 | How do I make a panorama?

A panorama is simply a picture that takes in a very wide view of a scene in one direction and thus shows far more than can be accommodated in one normal picture. Panoramas are different from the usual pictures achieved using wide-angle lenses (which produce a wide view in two directions). Most panoramas result in a very long but narrow picture.

Creating panoramas has become quite popular and several image-editing programs, such as Adobe Elements, have the facility to stitch several related pictures together to make a panorama. There are also

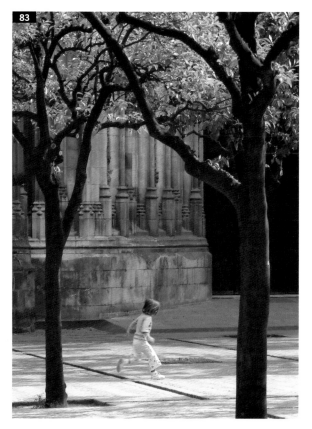

independent programs and plug-ins that help you create panoramas. One of the best, most versatile and easy-to-use shareware programs is the Panorama Factory from www.panoramafactory.com.

The basic process of making a panorama is to take several overlapping pictures of a scene, copy and paste them into individual layers in one file in your editing program, then correct any misalignment, colour and tonal differences to achieve a balanced result. Once all the pieces are correct, the layers can be flattened and cropped to reduce the file size ready for printing.

Making panoramas manually is not easy and I recommend using a specialist program.

Q83 | How can I use blur creatively?

Blur or image softness can be used in a variety of ways to add atmosphere, simulate movement, or increase the impact of a picture. Image-editing programs provide various Blur filters to help you create different effects.

The most utilized filter is Gaussian Blur, which is used to produce overall softening effects such as the simulation of differential focus (to make the background of a picture soft to accentuate the main subject). The next most useful filter is Motion Blur, which is used to create blur effects in a specific direction. This is good for simulating

83b **Applying Radial Blur**
To increase the ethereal atmosphere, I applied the Radial Blur filter to the second background layer and used the Layer options (double-click on the layer image) to blend this layer with the previous one. The Radial Blur filter allows you to select the point around which the blur will occur, so to direct attention to the girl, I centred the Radial Blur on her. The tones of the image were also lightened.

83c **Adding Film Grain**
To complete the picture I flattened all the layers and applied the Film Grain filter to produce a gritty effect. The result is this atmospheric, almost sinister, picture.

84

84 **Vignetted portrait**
This portrait of a young baby has been made more interesting by creating a vignette around the subject. To make the vignette, I created a new layer filled with a colour picked up from the subject's clothing. A Layer Mask was then added to this coloured layer and the shape of the vignette was drawn in using a soft-edged Brush. This method allows corrections and adjustments to be made without changing the portrait itself. To finish the vignette I applied some Film Grain to add texture.

linear movement such as a car passing in front of the camera. The third most useful filter in this group is Radial Blur. As its name suggests, this is great for creating rotational blur effects such as for rotating wheels or any other circular or curved movement. This filter can also simulate the blur effect created when the lens on a camera is zoomed during the exposure.

There are specialized blur filters available, such as Lens Blur in Adobe Photoshop, which allow a more accurate method of creating specific effects that are more closely related to the traditional results achieved with film-based cameras. Many of these filters have user-defined parameters for realizing just the right effect.

Q84 | How do I create vignettes?

The traditional vignettes used by photographers were either added at the taking stage by placing a cut-out shape in front of the lens, or in the darkroom when making the print (when the cut-out would be placed under the enlarger's lens). These methods produced a soft-edged shape around the main subject, to add interest. Vignettes differ from the decorative surrounds used in picture frames because they are actually part of the picture image and not simply placed over the top of a print.

The simplest vignette, seen in many portrait and wedding pictures, is a soft-edged oval shape. The soft edges of the vignette allow the picture image to fade gently into the white of the print background. Vignettes are easy to produce in an image-editing program by using a Layer Mask to hide the outer areas of the image. Draw the desired shape on the layer mask using the selection or drawing tools and feather the edges as desired. (If you use the selection tools, invert the selection and fill it with black to hide the outer parts of the image.)

If you want to create coloured or patterned vignettes, add a new layer above the picture and create the vignette on this layer. The picture underneath will show through the transparent areas of the vignette layer.

Q85 | How do I create frames?

Digital frames can be fun to create and will add interest to your pictures, especially those you intend to email to friends and family. Creative edges and digital frames around pictures are often used by digital artists either to simulate traditional techniques, such as the wrinkled effect of image separation (whereby the print emulsion of a photograph is floated off its backing and then applied to a new backing such as watercolour paper) or simply to produce a more interesting edge to the image.

To create an unusual edge or frame, either scan a real object, such as torn paper, or use the drawing tools to design a nice frame. Place the scan or drawing on a new layer and use the Blending modes to alter the effect.

85

85a

85 & 85 a Stormy sky

The frame for this image was produced by scanning a piece of torn paper. This frame was then placed on a new layer, in Screen mode, above the landscape picture. The 3D effect was created by duplicating the frame layer, inverting the tones, moving the frame a few pixels and finally setting the layer to Multiply Blend mode. The soft-edged surround was created with a soft, feathered selection and a Layer Mask.

85 c & d Bullring entrance

For a slightly more complex frame I drew some lines on paper and then tore out the centre portion before scanning the result. The centre section of this frame was used as a Layer Mask on the main picture. A new layer containing the full frame was then placed above the picture and set to Difference mode to provide the dark edge to the torn centre. The text was added and the toned effect applied using the Hue/Saturation command.

85c

85c

Bullring!

86 Marquee tools
This image shows just a few examples of the geometric selections possible using the Marquee selection tools. When you make a selection, the dashed lines move and are known as 'marching ants'.

86a Lasso and Polygonal Lasso
This image shows examples of selections possible with the various non-geometric tools such as Lasso and Magic Wand, and the type of shape/subject that each tool is useful for. Note that you can create soft-edged selections by feathering the selection. Combined hard and soft selections are also possible.

86b Colour Range command
The Colour Range command, like the Magic Wand tool, is used to make selections based on the colour values in the image. The dialog box shown here allows you to sample various colours or choose preset values, such as shadows, from the drop-down list. You can also load and save your colour range selections.

86c–e Saving and
loading selections

*Any selection can be saved
using the Select/Save Selection
command, which brings up the
Save Selection dialog box shown
here. Type a name for the selection
and save it to a new channel. The
selection is saved as an alpha
channel (see the Channels screen
grab). To reload a saved selection
use the Select/Load Selection
command, which brings up the
Load Selection dialog shown here.
Choose which selection to load
and whether to combine it with an
existing selection using the option
buttons in the dialog. It is possible
to create extremely complex
selections by combining previously
saved selections.*

Q86 | How do I use selection tools?

The selection tools found in image-editing programs are mainly used
to isolate specific areas of a picture in order to make some form of
enhancement to that area without affecting the rest of the image.
There are various types of selection tool, each used for a specific
purpose. The simplest are the Marquee tools, which are used to
create rectangular or oval geometric shapes. To use a Marquee tool
select the desired tool, click on the required starting point with the
left mouse button and drag the mouse to extend the 'marching ants'
border lines. The way the Marquee tools work can be modified by
using specific key combinations as the mouse is dragged. For
example, to define a perfect square or circle, hold down the SHIFT
key while dragging the mouse. Once a selection has been made it
can be added to, or subtracted from, by holding down the CONTROL
(COMMAND) or ALT (OPTION) keys respectively while dragging an
additional shape with the mouse.

To create non-geometric shapes use the Lasso tool, which can be
dragged around an object to select a complex shape. For straight-
sided polygons, use the Polygonal Lasso or Magnetic Lasso tools. The
Polygonal Lasso is ideal for making selections around items that have
straight edges. With this tool selected, the first click of the mouse in
the image anchors a 'rubber band' line that will move with the
mouse. Each additional click of the mouse defines a corner for the
selection. To close the shape, click on the original starting point. The
Magnetic Lasso is a combination of the other two. It is used to create
irregular shapes around objects that have well-defined irregular
edges. The Magnetic Lasso attaches itself to the object edges as you
drag the mouse around the edge of the object. This can be faster and
easier than using the Lasso tool.

Other selection tools are available for making selections based on
the colours in the image. These are pixel selection tools. The most
frequently used tool is the Magic Wand tool, which selects pixel

Channels		**86d**
	RGB	Ctrl+~
	Red	Ctrl+1
	Green	Ctrl+2
	Blue	Ctrl+3
	Shapes	Ctrl+4

Load Selection **86e**

Source

Document: Q86_Selections1.psd

Channel: Layer 3 Transparency

Layer 3 Transparency

Shape

OK

Cancel

Operation
- ● New Selection
- ○ Add to Selection
- ○ Subtract from Selection
- ○ Intersect with Selection

colours based on the tolerance value chosen. The tolerance value controls the range of colours the Wand will chose each time it is clicked. The higher the value, the more pixels of a similar colour to the original pixel will be selected when the Wand is clicked in the image. The Colour Range command allows you to specify a range of colours to select and is also a very useful selection tool.

Once a selection has been made it can be saved for future use. This is particularly important for complex selections that may take considerable time to produce. Saved selections are placed in their own colour channels and can be reloaded or modified as desired.

Q87 | How do I use Brushes?

All image-editing programs provide a range of tools, called Brushes, which are used for painting on a digital image. Brush tools work with the actual image pixels and are known as raster-based tools (digital photographs are raster images). Most programs have a range of preset Brushes that can be used simply by selecting the Brush from a Brush palette. Each Brush has a set of attributes that control how it will apply the chosen colour to the image. Attributes such as Brush Size, Tip Shape, Edge Softness and many others can be configured by the user to produce just the effect desired.

To paint with a Brush in Photoshop, select the Brush tool and then either choose a preset Brush from the Brushes palette or create a new Brush. You can save your custom Brushes either in the preset Brushes palette or in your own Brushes files. These custom Brush files can be loaded in when needed. Adobe Photoshop comes supplied with a variety of custom Brush palettes that can be loaded from the Brush palette menu.

87 & 87a Choosing a Brush
When you click on the Brush tool you are given options for controlling the Brush. The first decision is the shape and size of the brush you require. This is done via the brushes palette, shown here. There are many sets of preset Brushes that can be loaded into the palette or you can design your own Brushes and save them.

87b

87b Painting with Brushes

Once you have chosen your Brush, you can paint on the image in any way you like. This simple painting of a meadow was done using a variety of Brushes. I started by painting the grass with various sizes of the pre-defined Grass Brush using different shades of green. I then used one of the preset Flower Brushes to paint in the coloured meadow flowers. The butterflies were created with another preset Brush then coloured and manipulated in various ways. Not a masterpiece, but it was good fun to play and explore some of the Brush possibilities.

For the greatest control when using Brushes (and many other editing tools) it is best to use a drawing tablet and stylus, because the mouse is very difficult to control for drawing purposes. Drawing tablets have pressure-sensitive controls that allow the user to simulate traditional drawing.

Q88 | How do I use the Pen tool?

One of the most versatile drawing tools, and one that it is important to master, is the Pen tool. The Pen tool is a drawing rather than a painting tool (such as the Brush tool) and produces vector-based drawings. One major benefit of the Pen tool is that it is easy to use with a mouse and can produce very accurate results.

Vector tools are based on mathematical formulae and produce a series of lines, either straight or curved, connected by control points called nodes. With the Pen tool selected, each time you click the mouse in the image it creates a new node. Each node is automatically connected to the previous node with a line segment. In this way you can create very complex geometric shapes. To create a curved line segment, click and drag the mouse. A curved line will be created, connected to the previous node. As you drag the mouse, the shape of the line will change, becoming fixed when you release the mouse button. To close a vector shape, simply click again on the starting point node.

88 Corner node

A single click of the Pen tool creates a corner node which produces a sharp turn in the path. The elastic band option was activated so the path from the Pen tool is visible.

88a Symmetrical node

Click and drag to create a smooth node: the path enters and leaves the node smoothly to form a symmetrical curve.

88b Closing a path

The path can be closed or open-ended. To close the path, click on the starting point: a small circle is visible next to the Pen icon to show that the path can be closed.

88c Adding nodes

Additional nodes can be created on the path, to use when making a complex path.

88d Deleting nodes

Nodes that are no longer required can be deleted from the path, which then adapts the nodes on each side of the deleted node to define the shape.

88e Converting nodes

Use the Node Convert tool to change the type of node, or to move the node handles independently to create combination nodes so that the path curves in and out of the node in an asymmetric way.

88f Paths palette

Once you have designed a path using the Pen tool, it is stored in the Paths palette, shown here as a work path. It is important to drag this work path to the New Path button at the bottom of the palette to save the path for future use. The Paths palette also allows you to make a selection from a path, stroke or fill a path, or delete a path.

Once a vector shape has been created, it can be edited using the Direct Selection tool. This tool allows you to click on any node and move the control handles that appear in order to change the shape of the line segments. Thus you can continue to refine the shape until it is exactly what you want.

In Photoshop, shapes created with the Pen tool are placed on their own layers and can be edited at any time.

Q89 | How do I use layers?

Image layers are like sheets of transparent plastic stacked one above the other. Each layer in the stack can have items placed on it without affecting whatever is on the other layers. A layer can contain photographic images, text, or drawn artwork in any combination. Individual layers can be named, moved up and down the stack, duplicated or deleted as required. Each layer can also be given its own Blending mode and Opacity setting.

The order of the layers determines how the visual elements of each layer overlap; elements on the lower layers are overlaid by those on the layers above. The Blending mode determines how the colours on each layer interact with the colours on lower levels (it has no effect on layers higher in the stack). There are many different Blending modes to choose from, and a close study of each mode's effect is worthwhile. The Opacity setting controls the transparency of items on a layer, making it possible to have the contents of lower layers showing through.

The content of each layer can also be masked, using a Layer Mask, to hide unwanted parts of the layer or to create special effects. This layer mask is stored in an alpha channel in the same way that selections are stored. Layer Masks can be drawn and painted on with all the editing tools, including filters, to create complex masks.

Adobe Photoshop allows several layers to be grouped into a layer set. A layer set can be colour-coded and the whole set masked using only a single Layer Mask. This makes working with complex multi-layered images much easier and more efficient.

Layers are very powerful and allow you to composite images to create complex montage and collage effects. When working with layers, the file size will grow significantly so a good tip is to flatten any layers that you know will not require further adjustment. This keeps the file size more manageable.

89 **Windmill and moon**

This composite image of a sky, moon and windmill required several layers to achieve the desired result, as shown in the accompanying screen grab of the Layers palette.

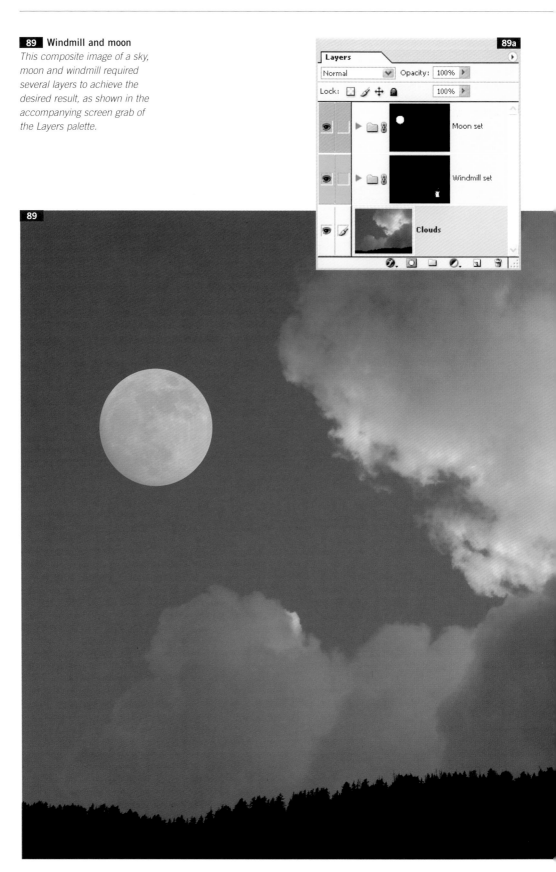

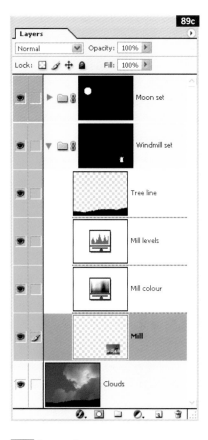

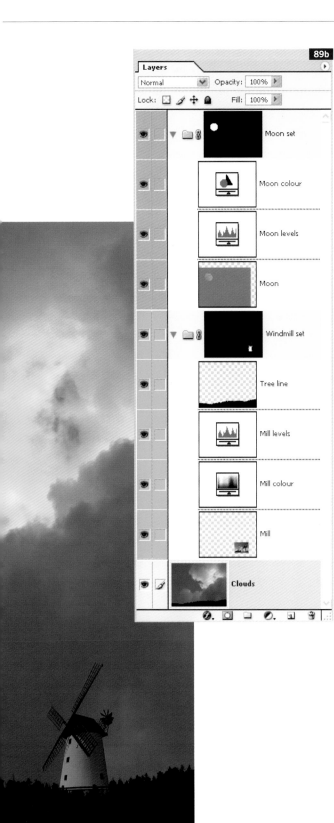

89a Layer sets

When creating a complex layered image, it helps to group the various associated layers together in layer sets. As shown in this screen grab, named layer sets greatly simplify the Layers palette.

89b Working with layer sets

You expand and collapse a layer set by clicking on the small arrow. A layer set can contain any type and number of layers in any order. Here I have expanded the Moon set to show the three layers within the set. Note also that the set layers are colour-coded to aid recognition.

89c Masking a layer set

One of the useful features of a layer set is the ability to create a mask that affects all the layers in the set. A mask of the layer set is shown in this screen grab of the Windmill set. This avoids the need to have a layer mask on each individual layer of the set.

90 Trees in the clouds

*Making a photomontage is very easy if you
use individual layers for each element of the
composition. As shown in this simple example,
by placing the trees on one layer and the cloud
on another, I was able to modify each layer
separately to achieve the desired result. Changing
the Blending mode and Opacity settings of the
layers helps you merge layers together.*

Q90 | How do I make a photomontage?

A photomontage is created by compositing two or more images together to form a new image. The commonest example of this is when the blank sky of one picture is replaced by a more interesting sky from a different picture.

To form a montage, start by placing each element of the composition on its own layer, then use the editing tools to make the various elements fit together. This may involve changing the size and position of the elements, adjusting the colour balance, brightness and contrast, and applying any desired effects to blend the elements into the final picture.

Montages can be simple, perhaps using only two elements, or very complex, for example a dramatic surrealist image.

Q91 | What are channels?

Channels are special 8-bit greyscale layers that are used to store the colour information of an image. In an RGB colour image, there are three colour channels, one each for the Red, Green and Blue information. Traditional photographers can think of these layers as high-cut filters.

In a CMYK image there are four channels: one each for Cyan, Magenta, Yellow and Black (K). A greyscale image (i.e. a black and white photograph) has only one channel, representing the range of grey values in the picture.

91 RGB image
This RGB image has three channels, as can be seen in the screen grab of the channels palette. Each channel stores the tonal information for one of the primary colours – red, green and blue.

91a–d Channel greyscale images
These three greyscale images show how the tonal range is divided among the colour channels. For example, where there is red in the image the red channel will contain information. Examination of the colour channels can help when deciding how to manipulate an image. For example, when converting a colour image to mono, it can be useful to examine the channels first to determine which channel should dominate in the channel mixer dialog box during the mono conversion.

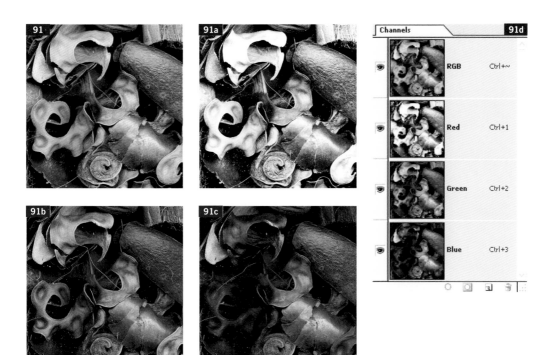

Rusty car
When you make a selection using any of the selection tools, the selected area is stored in a new channel known as an alpha channel, as shown in the channels palette for this picture of a rusty car.

92b **Greyscale channel**
This is how the greyscale channel image looks. Since an alpha channel is simply an 8-bit grayscale image it can be manipulated using most of the available tools and filters. In this example you can see that I have reduced the density of the rear half of the car. This is now known as a density mask (rather than simply a black and white mask). Density masks allow you to make proportional changes to the image. For instance, if a filter is applied using this selection as a mask, the filter will affect the darker areas more than the lighter ones.

Q92 | What are alpha (or mask) channels?

Channels are used to store saved selections and when used for this purpose they are referred to as alpha or mask channels. Alpha channels are very powerful and a good understanding of their flexibility will expand your usage of the image-editing program.

Since channels are simply greyscale images, they can be modified using most of the editing tools. In this way it is possible to create very complex selections utilizing a mixture of hard and soft edges and variable opacity. Mask layers that have a range of different densities of grey are often referred to as density masks. Density masks are used to control the amount of a particular adjustment being applied to the image, making it easy to apply filters and effects proportionally.

Q93 | How do I use the Channel Mixer?

The Channel Mixer takes the greyscale values found in the three individual colour channels and mixes them in the proportions specified in the Channel Mixer dialog box to produce an output channel. If the Monochrome box is checked, the result will be a black and white image, otherwise the colours of the picture will be altered.

The best way to experiment with the Channel Mixer is to add a Channel Mixer adjustment layer above the colour image. This allows you to make changes without affecting the original image.

There are three main uses for the Channel Mixer: to adjust the colours in the image, to create a hand-tinted look, or to convert a colour image to monochrome. Using the Channel Mixer to alter colour can produce either subtle or dramatic results. The Channel Mixer can produce some bizarre colour changes unobtainable in any other way.

To produce a hand-tinted effect, first select from the drop-down list the channel that will be the Output channel (Red, Green or Blue) and click the Monochrome box. Now immediately uncheck the Monochrome box. This creates a monochrome image that will accept colour. When the Source channel sliders are moved, subtle colour effects will be introduced to the image. Note that the greater the percentage changes, the more pronounced the colour effects will be.

The third use of the Channel Mixer is to convert from a colour to a monochrome image. This is the most versatile method of conversion, since it allows you to control the tonal relationships in the final monochrome image. This is similar to using camera contrast filters in traditional black and white photography. Before using the Channel Mixer, examine the colour channels on the Channels palette and decide which channel gives the closest result to the image you want. Now add a Channel Mixer adjustment layer and select the best colour channel in the Output channel drop-down list. Experiment by adjusting the percentage values of the Source channels with the sliders until you have the result you desire. The Constant slider is used to lighten or darken the Output channel. For editing programs

93

93, 93a & b Leaf

For this simple close-up of a leaf I wanted to add more contrast and change the colour. Adding a Channel Mixer layer to the image allowed me to produce the desired colour. The values used can be seen in the screen grab of the Channel Mixer dialog.

93c & d Chateau courtyard

I wanted to transform this colour picture into a more atmospheric result that emphasized the heat of the sunshine blazing down. To do this I used a Channel Mixer layer to create a multi-toned image (click in the Monochrome box twice in the Mixer dialog). I also used the Channel Mixer Layer Mask to bring back a portion of the original green leaves, as shown in the Layers screen grab.

93e–g Channel Mixer values

These screen grabs show the values used to create the colours in the chateau picture.

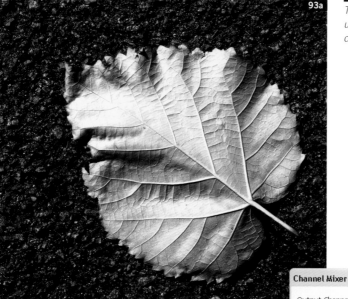

93a

93b

Channel Mixer

Output Channel: Blue

Source Channels

Red: +90 %

Green: 0 %

Blue: +30 %

Constant: 0 %

☐ Monochrome

OK
Cancel
Load...
Save...
☑ Preview

93c

93d

Layers 93e

Normal Opacity: 100% ▶

Lock: ☐ ✎ ✤ 🔒 Fill: 100% ▶

Ch. Mixer

Levels 1

Background

Channel Mixer 93f

Output Channel: Green

Source Channels

Red: +94 %

Green: -32 %

Blue: +48 %

Constant: 0 %

☐ Monochrome

OK
Cancel
Load...
Save...
☑ Preview

Channel Mixer 93g

Output Channel: Red

Source Channels

Red: +62 %

Green: -46 %

Blue: +124 %

Constant: 0 %

☐ Monochrome

OK
Cancel
Load...
Save...
☑ Preview

94

94 Olive landscape

This landscape was made in slightly hazy conditions which have resulted in the middle and far distance details becoming very soft. I decided to try to simulate more detail using the Paint Daubs filter on the distant parts of the scene only.

without a Channel Mixer you can achieve the same results by adjusting the individual colour channels using the Levels command.

Note: for the optimum quality it is recommended that the total of the Source channel percentages adds up to 100 per cent.

Q94 │ How do I use the History palette?

The History palette is a record of each of the changes you make to an image. You can jump to any previous state of the image created during the current working session. Each time you apply a change to an image, the new state of that image is added to the palette.

For example, if you select, paint, and move part of an image, each of those changes is listed separately in the palette. You can then select any of the states in the palette, and the image will revert to the way it looked when that change was first applied. This is useful for undoing recent changes. You can specify the maximum number of

items to include in the History palette and set other options that customize the way you work with the palette. You can also create a new document from any History palette state by selecting it and clicking the Create New Document button at the bottom.

Related to the History palette is the History Brush tool. This tool lets you paint a copy of one state, or snapshot of an image, into the current image window. A snapshot is a temporary copy of the current image state, created using the Create New Snapshot button on the History palette.

The History Brush makes a copy of the chosen state and then paints with it. For example, you might create a snapshot of a change you made with a painting tool or filter (with the Full Document option selected when you create the snapshot). After undoing the change to the image, you could use the History Brush tool to apply the change selectively to areas of the image. This is a good way to apply selective filter effects.

94a & b Paint Daubs

The first step was to apply the Paint Daubs filter to the whole image. I created a snapshot of this result using the Create New Snapshot button on the History palette. I then moved back one step in the History palette to go back to the original image. Now the background from the snapshot could be painted using the History Brush tool (click in the box next to the History palette snapshot before painting).

95

95a

95 Old station

This 'before' picture of an old railway station in evening light is a good candidate for the application of one of the artistic filters from the Photoshop range.

95a Painterly old station

Here we see the station image following the application of the Paint Daubs filter. Most pixel-crunching filters work best on pictures with good areas of detail and colour, since this makes the effect of the filter more apparent.

Q95 | What are image filters?

Image-editing programs are usually supplied with a range of special effects filters. These image filters range from the relatively simple, such as blurring filters, to the very sophisticated, including lens flares and even realistic sky-creation filters.

What all these filters have in common is that they manipulate the pixel data of the picture in different ways to create their respective effects. Since image filters change the actual data in the file, the more filters you use on an image, the more degraded the image data becomes. This can eventually lead to an unsatisfactory level of quality loss. Just as in traditional photography, if quality is your prime concern, the rule is to use the minimum number of filters in order to preserve image integrity.

Many image-editing programs use the Adobe Photoshop standard for implementing image filters. This means that there are literally hundreds of third-party add-on filters (known as plug-ins) that can be purchased to extend the range of filters built into the original editing program.

Q96 | How do I sharpen an image?

The digital capture process, whether it is achieved by camera or scanner, inherently produces slightly unsharp results which, if printed without improvement, will look disappointing. Therefore, all digital image files will require some form of sharpening prior to printing. There are different ways to sharpen an image and the method you choose will depend on the type of image you are dealing with and the visual result you desire.

The most common image-sharpening technique is known as Unsharp Mask (USM). USM is based on a traditional photographic technique and is very easy to implement using an image filter (usually found on the Filter menu under Sharpen). One problem with USM is that it can result in an increase in graininess in smooth areas of tone such as blue skies.

A more advanced technique, which is based on the high and low frequencies of image detail, is to use the High Pass filter. The high Pass filter suppresses the low-frequency information but retains the high-frequency data. Since areas of the image with good detail are high frequency and areas of smooth tone are low frequency, this filter only accentuates the contrast of detailed areas.

Generally, the whole image is sharpened during this process, but this is not necessarily the best approach in every case. There will be occasions when it is more appropriate to sharpen only selected areas of an image. For example, a relatively soft sky with clouds may look better with no sharpening so as not to accentuate the graininess of the smooth tones, while the foreground detail of the picture may require sharpening.

Q97 | How do I use the Unsharp Mask?

The USM filter uses the Threshold value to find neighbouring pixels that differ in value by the threshold amount. It then increases the contrast of those pixels by the percentage specified in the Amount value. Therefore, light pixels get lighter and dark pixels get darker. Additionally, you can specify the radius of the region in which pixels are compared. The greater the radius, the greater the halo effect that results from over-sharpening. The result of these changes to the pixels is a perceived increase in image sharpness. Since this process works best on detailed areas of an image (because the pixel values differ most in these areas), pictures with large areas of smooth tone may not show much sharpening other than an increase in digital graininess, and may benefit from the High Pass sharpening method.

Before starting, zoom the picture to 100 per cent so that you will see the effect of the filter on the main image at full size. To use USM, select the areas you wish to sharpen or simply make sure the picture layer is active, go to the Filter/Sharpen menu and activate the Unsharp Mask command. The dialog box opens showing a preview

97a

97 Unsharpened picture

This highly detailed picture of needlecraft is a prime candidate for the sharpening effect of the USM filter.

97a & b Sharpened picture

By applying the USM filter to the picture, all the details are enhanced. The amount of USM needed for a particular picture depends on the type of image and the image size. Larger image sizes need more USM. This picture required the values shown in the screen grab of the USM filter dialog box.

97b

Unsharp Mask

OK

Cancel

☑ Preview

⊟ 100% ⊞

Amount: 150 %

Radius: 1.0 pixels

Threshold: 1 levels

of a section of the image and the three parameters – Threshold, Radius and Amount – that you adjust for the desired result. As a starting point, set the Threshold value between 1 and 4 levels and set the Radius to between 1 and 2 pixels. Increase the Amount value and examine the change in the main image window. Experiment with the values until you have a result you are happy with.

The exact amount of USM for a particular image depends on several factors: the type of image, how sharp it is to begin with, whether it contains lots of detail, the file size, and the intended output medium. Large image files usually require more aggressive USM, as do images intended for high-quality print output. Images destined for the Internet or to be viewed on a monitor may require only a small amount of USM. Experiment with different settings to discover what works best for your particular way of working. When making prints the screen image may look over-sharpened, but in the actual print it may well be fine.

Q98 | How do I use High Pass sharpening?

Using the High Pass filter for sharpening is usually better for images that contain a combination of both detail and smooth tones. Unsharp Mask sharpening tends to increase the graininess of the smooth tones, whereas the High Pass method avoids this problem.

First make a copy of the image layer and place it above the original. Change the Blending mode of this layer to Hard Light (this allows you to preview the effect of the filter). Apply the High Pass filter (Filter/Other menu in Photoshop) adjusting the Radius figure as necessary to achieve the right degree of sharpness.

Q99 | How do I simulate lith prints?

Lith printing is very popular among experienced darkroom printers as a way of producing beautiful images with unique qualities. The main features of a lith print are grainy shadows, smooth light tones, and often two or more subtle colours in different parts of the tone range – cool shadows and peachy light tones.

To replicate this digitally, copy your image to two new layers, one for the light tones and one for the shadows, and colour each layer with the desired colour (as for mono toning). Adjust the Layer options of the shadow layer to restrict the tonal range. Now copy the shadow layer and apply additional grain using the Noise filter. Change the Blending mode to Hard Light. The amount of grain is a personal choice, but try to be subtle. This image is placed above the shadow layer and has its opacity reduced to achieve the look you want. Above these three layers add a Levels adjustment layer and move the mid-tone slider towards the black end of the scale. This will lighten all the shadows and high values while producing a simulation of lith shadows. The result is an image with the look and feel of a lith print.

98 Battlements
This picture of castle battlements was taken from some distance using a hand-held long telephoto lens. The result is a rather soft image that requires some serious sharpening. Since I wanted to minimize the impact of the sharpening on the smooth tones of the sky, I decided to use the High Pass filter method.

98a & b High Pass filter
This is the result after applying the High Pass sharpening. As can be seen from the Layers screen grab, the image was copied to a new layer and the High Pass filter applied to this layer. The Blending mode of the High Pass layer was changed to Hard Light to apply the effect to the original image.

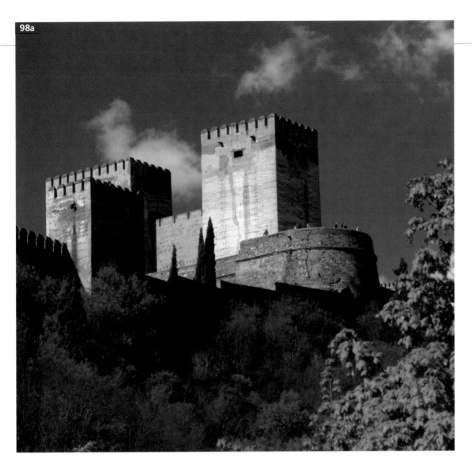

98a

98b

99 Old house

The backlighting and general ambience of this old house in the city of Granada, Spain, lends itself to conversion to a lith-style picture. The first step was to use the Channel Mixer to convert the image to a monochrome RGB image. Next, I created three copies of the image on new layers.

99a Toning the image

The bottom layer was toned using the Hue/Saturation/Colourize method to produce quite a strong orange colour. (This colour would later be altered by fine-tuning.)

99b Lith conversion

The middle layer was used to make the shadows appear blacker by increasing the contrast of this layer. I then adjusted the Layer options (see screen grab) to eliminate the lighter tones and reduce the Opacity to 50 per cent. The top layer was used to add grain to the image by applying the Film Grain filter to this layer. The Blending mode was changed to Hard Light so the grain affected only the lower tones and kept the lighter tones smooth.

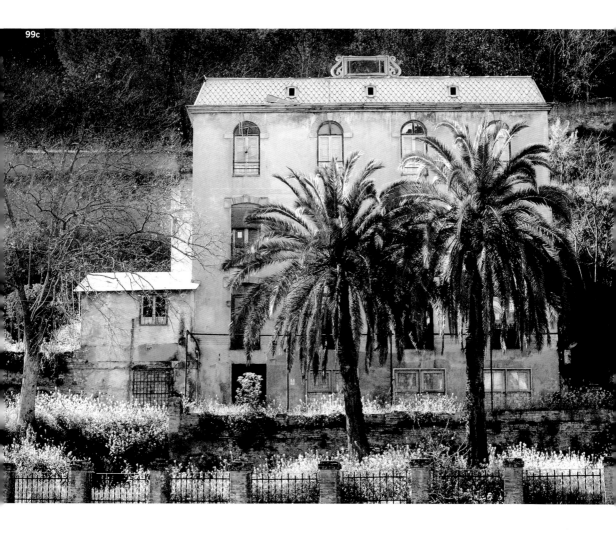

99c

Layers			99d
Hard Light	☑	Opacity:	100% ▸
Lock: ☐ ✐ ✛ 🔒		Fill:	100% ▸

👁 Levels

👁 ✐ **Grain**

👁 Dark tones

👁 Light tones

99c & d Lith treatment

This is the final result after applying a Levels adjustment layer above the other layers. The Levels layer is used to fine-tune the tonal values and lighten the overall colour. See the Layers palette screen grab for the final arrangement.

File management

Q100 | How do I manage image files?

It doesn't take long for a digital photographer to amass hundreds of pictures, and it quickly becomes apparent that the space on your hard drive diminishes at an alarming rate. When you consider that a digital camera of reasonable quality may produce a compressed JPEG file of around 2.5 MB, it isn't difficult to appreciate that the average hard disk will soon be bursting at the seams. The problem becomes much worse if you save files in uncompressed TIFF format or start to produce multi-layered Photoshop files, which may easily be 30 MB or larger.

The answer is to have a routine of storing your image files on external media such as DVDs. Although a single DVD can store much more than the older CD format, it still makes sense to try to make the image file sizes as small as possible. There are different ways of doing this but an important consideration is picture quality. Always store a master copy of each picture using a lossless compression method to retain the highest quality. The usual method is to save the image as a compressed TIFF, using one of the lossless options such as LZW.

There are also third-party software programs that specialize in image compression and one of the best is considered to be the Genuine Fractals PrintPro Photoshop-compatible plug-in from Altamira. This program not only compresses image files, but when you open one of these files you can specify the scaling of the image. This scaling is achieved with minimal image degradation and is an ideal way to produce different print sizes from one compressed file. The downside is that the images are stored in a proprietary format denoted by the extension '.stn' and they cannot be opened without the Genuine Fractals plug-in.

As well as the storage issue of having multitudes of image files, an equally important task is the cataloguing of all those pictures. Most photographers need to be able to find specific types of pictures quickly – for example, all sunset images taken in the UK – and locating a particular shot can take hours of searching if you have to keep loading and viewing stacks of DVDs to find what you are looking for. The solution is to use a good image-cataloguing and database program.

One of the most respected of these cataloguing programs is Portfolio from Extensis. It provides all the features you are likely to need to keep your image resources in a managed state. The program produces thumbnail images of all the pictures in a specified location and allows you to add captions and other information you need for each image. A specified set of image thumbnails can be stored as a catalogue on your local hard drive in a small database. By building a

100 TIFF Options dialog
When you save an image file from an editing program, you can usually choose from various file formats in which to store the image. The most popular lossless compression format is the TIFF format and this screen grab shows the TIFF Options dialog presented to the user by Photoshop. Here you can chose different compression options; LZW is the lossless format.

100a JPEG Options dialog
This screen grab shows the JPEG Options dialog from which you can select the level of compression desired. For many images, compression values of high or maximum will not show any visible degradation of the image, but may significantly reduce file sizes. The efficiency of the compression ratio is determined by the detail level of the image. Images with lots of smooth tones, such as sky, tend to compress more than other images.

100b Genuine Fractals
When using the GF plug-in to save a file, you are presented with this dialog where you choose whether to use lossless or lossy compression.

100c GF Load File dialog
When you wish to load a file that has been saved in the GF '.stn' format, this dialog opens, giving you lots of choices about how the image will be loaded. Here you can specify enlargement, resolution and other parameters. You can also use the small preview box to crop the image, as shown here.

100d Portfolio catalogue
This dialog shows the working window of the Extensis Portfolio cataloguing software. This is a full-featured, professional program that makes indexing and searching for images much faster and easier than simply using the folder system of either the Windows or Mac operating systems.

system of these catalogues, you can search efficiently through your entire stock of pictures to find the image you need and then load a single DVD.

Q101 | How do I make contact sheets?

The traditional method used by photographers to catalogue their negatives and transparencies to produce a visual reference is to make a contact sheet. Contact sheets (or more simply 'contacts') are prints containing small images of a set of negatives. The term 'contact sheet' is derived from the fact that a film of negatives is cut into strips which are then placed in contact with the print paper to make the contact sheet.

Since this is still a useful way of referencing images, most image-editing programs provide some method of creating digital contact sheets, which can then be printed and used more conveniently than working at the computer.

Some programs, such as Adobe Photoshop and Elements, provide a dedicated command for creating contacts. This command allows you to select the folder containing the images and to specify other items such as the number of rows and columns on the contact sheet.

101 Contact Sheet II
Making contact sheets is relatively simple using the Contact Sheet II plug-in provided with Adobe software. This is the dialog window where you specify the various parameters for the contact sheet.

101a Sample contact sheet
This is a sample contact sheet produced from the parameters shown in the previous dialog box. This sheet can now have additional information added to it if needed using the Text tool, and can then be printed and filed for reference purposes or sent to clients.

If you want to make a contact sheet with images from different folders, it is necessary to bring them together into one folder first. With other programs that do not have a dedicated contact sheet command, such as Paint Shop Pro, it is necessary to use the facility that permits printing several images on one page and to build up the contact sheet manually.

Glossary

Additive colour Additive synthesis is the method of adding the primary colours of light (Red, Green, and Blue) together to form white light. All display monitors use additive colour to create pictures on the screen.

Aliasing A method of adjusting the edge contrast of adjacent square pixels in a displayed image so that curved shapes and diagonal lines look smoother. With aliasing turned off, diagonal lines and curves have a stepped appearance known as 'the jaggies'.

Alpha channel A greyscale image stored in a separate image channel and used to define masks and selections. In an alpha channel, white areas are transparent and black areas are opaque. Any bitmap or greyscale image can be used as an alpha channel.

Anchor points Adjustable points attached to nodes and used to control the tension in the curved lines and corners of a vector path. See also Nodes.

Artefacts Image defects caused by data manipulation – either in a digital camera, often seen as digital 'noise', or later in the image-editing program. Heavily manipulated images, especially, should be carefully checked for artefacts prior to final saving.

Background printing A method of storing a document or image in a computer's memory and printing it as a background job controlled by the operating system's print engine. This allows the computer user to continue working normally whilst the document is being printed.

Bit A binary digit, or bit, is the smallest data unit that can be stored in computer memory. A bit can contain either 0 or 1, be on or off (like a light switch), or represent any one of two different states of existence.

Bit depth The bit depth specifies the number of bits used to store the colour data in an image file. Also known as colour depth, an image with a high bit depth can contain a greater range of colours than one with a lower bit depth. For example, a 48-bit colour image uses 16 bits of storage for each separate RGB pixel value; a 24-bit image only uses 8 bits for each RGB value.

Bitmap A bitmap image is stored as a collection of single bits, each of which can only store either black or white. Thus a bitmap can contain only a combination of two tones, black or white. This format is ideal for black and white line art.

Blending A merging of the colour and tonal values of two or more pixels (the base colours) in a layered image to create a single final colour (the result colour).

Bump map Normally a greyscale image that is used with texturing and lighting effects filters to create the impression of surface texture or roughness. Widely used in 3D software and also used by Adobe Photoshop's Texturizer and Lighting Effects filters.

Burn A technique derived directly from traditional darkroom printing and used to selectively darken, or burn in, areas of an image. Most image-editing software has a Burn tool.

Byte A byte contains eight bits which, in the binary number system, means it can store the range of numbers from 0–255 (256 different numbers). Bytes are used to store the individual grey values of an 8-bit greyscale image.

Card reader Digital cameras store their images on memory cards, which can then be read directly with a card reader. Card readers can be either internal or external devices attached to a computer.

Cast A visible but unwanted colour that affects the whole or parts of an image. Referred to as a colour cast, it is usual to remove it to improve the colour balance of an image. Colour casts are very common in digital camera images that have been taken in unusual lighting situations.

CCD A CCD, or charge-coupled device, is a light-sensitive electronic chip found in digital cameras and scanners, which responds to image-forming light. Differing light levels, i.e. light and dark tones, produce more or less electrical response within the CCD. These signals are then refined to form the digital image.

Chroma The intensity, or purity, of a colour and thus its degree of saturation.

CIS A CIS, or contact image sensor, is a new alternative device to the standard CCD. It is gradually becoming more common in scanners, because it produces higher resolution values than a CCD.

Clipping The term used to describe the loss of subtle highlight and shadow tones near the extremes of black and white. This is often a problem when scanning film with a density range that exceeds that of the scanner, resulting in a loss of fine detail and increased contrast. Clipping also occurs when an image is over-corrected in an image-editing program.

CMYK mode Cyan, Magenta, Yellow and Black (called 'K' as it is known as the 'Keying' tone in printing and to avoid confusion with Blue) is the image mode used for digital files destined for lithographic printing in books and magazines. CMYK images are printed with pigment inks and thus have a smaller colour gamut than RGB images.

Colour picker A colour model displayed by image-editing programs and operating systems, which allows the user to select any colour from the available colour space. Colour picker dialog boxes can be set to show the range of colours in both a visual display and in different numeric colour models, e.g. RGB, HSB etc.

Colour space Colour spaces are scientifically formulated ranges of colours used to help produce standardization in the printing industry. The most common colour spaces used for digital images are RGB and CMYK. Each colour space has its own range or gamut of colours and is intended for a specific purpose.

Colour temperature The temperature, measured in degrees kelvin, to which a one-inch square black body would need to be heated to produce a specific colour of light. The Kelvin Scale of colour temperature is used to quantify the colour of both natural (daylight) and artificial (light bulbs) light sources.

Compression Using sophisticated mathematical algorithms, digital image data can be rearranged to fit into smaller file sizes without compromising image integrity or quality. Known as compression, this process can be either lossless (all original data is maintained) or lossy (some repetitive image data is removed in order to gain more compression but with a slight reduction in image quality). See TIFF and JPEG.

CPU The CPU, or central processing unit, is the 'brain' of a computer and performs all the complex mathematical calculations needed to manipulate image data. The speed of a CPU is measured in megahertz or, more recently, gigahertz. The higher the gigahertz, the more powerful the CPU.

Curves Curves are a graphical interpretation of the tones and colours found in an image file. Displayed as a x–y graph, the contrast, tones, and colours of an image can be adjusted by changing the shape of the line on the graph. The shape of the curve is usually adjusted by pushing and pulling the line.

CRT A CRT, or cathode ray tube, is used to display the picture on computer monitors and televisions. A computer monitor's CRT displays an image of far higher quality than a normal television screen.

Density Photographic density is a logarithmic measurement of the light absorption of a tone in a negative or print. See also Opacity.

Density mask A more advanced form of alpha channel that uses intermediate shades of grey to provide differing degrees of transparency. Density masks are used when an effect, such as a filter, needs to be applied more in some areas of an image and less in others. Any greyscale image or selection can be used as a density mask.

Density range The difference between the lightest and darkest tones in an image. Density range, or Dr, is often used to indicate the contrast of an image, i.e. an image with a density range of 3.1 will have more visual contrast than an image with a density range of 2.4. In

practical terms, a scanner that can record a density range of 3.5 will produce more useable tones from a negative of Dr3.4 than a scanner that only has a density range of 3.2.

Descreening A technique used by scanning software to remove the halftone screen pattern found on lithographic images printed in magazines and books. Descreening also prevents the formation of moiré patterns.

Diffusion dithering The random arrangement of ink droplets on a print to simulate continuous tones and colours. This produces more apparent colours than using the traditional grid printing system.

Digital zoom A method used by digital cameras to simulate a telephoto lens. Usually, a selection of the pixels in the centre of a recorded image is enlarged by interpolation to form a bigger image.

Dithering The technique of simulating complex colours and tones using only a few different ink colours. When placed very close together, the colours appear to merge into a single colour or tone.

Dodging Dodging is the opposite of burning in. This darkroom technique is used to selectively lighten (or dodge) parts of a print. Most image-editing programs have a Dodge tool that can be used to similarly lighten areas of a digital image.

Dot pitch A unit of measurement used to express the fineness of the shadow mask on CRT monitors. Smaller values produce sharper displays. A typical value for dot pitch is 0.26.

Dpi Dots per inch, or dpi, is used both as a measure of the sampling resolution of a scanner and also as a measure of the number of ink droplets deposited by a printer. In both cases, the higher the number specified for dpi, the higher the quality of the image produced.

Duotone A duotone is a printed monochrome image that uses two different ink colours to produce the tonal range. It is often used to extend the tonal range of the printed result and to tone a monochrome image with subtle colour.

Dye-sublimation A dye-sublimination, or dye-sub printer uses a ribbon coated with CMYK pigment and special paper to transfer image colours.

Dynamic range A measure of the useful tonal range of photographic materials and digital sensing devices. The higher the dynamic range, the greater the range of tones. Dynamic range is *not* the same as density range.

EPS EPS, or encapsulated postscript, is an industry-standard file format used for images and complete page layouts. This format can be read by most image-editing and page layout software.

Eyedropper A tool used in image-editing programs to select a specific colour from an image. It is very useful when you need to match the exact colour contained in an image, such as when working with company logos, or when creating a matching coloured border.

Filename extension The three- or four-letter code preceded by a full stop (or period), attached to the end of a filename e.g. 'MyImage.tif'. The filename extension is used by applications to identify the type of the file and to assist with cross-platform compatibility.

FireWire FireWire (or IEEE1394) is a fast data-transfer protocol used specifically for transferring large image files and digital video.

Gamm A measure of the mid-tones of a digital image. Adjusting the gamma of an image lightens or darkens the middle tones without altering the white or black points.

Gamut The specific range of colours contained in a colour space or colour palette.

GIF GIF, or graphics interchange format, is specifically designed for web or low-quality images. It uses only 256 colours or fewer and is ideal for Internet images, coloured artwork or thumbnail photo images, because of the small file sizes.

Greyscale Greyscale mode has 256 different grey values, and is used to store and display continuous tone black and white images. Only 256 greys are needed to produce a graduated tone that the human eye perceives as continuous, i.e. without banding.

Halftone An image constructed using a dot screen of different sizes to simulate continuous tone and colour in lithographic printing. Used for printing pictures in magazines and books.

Highlight The brightest tone in an image represented by the value 255 on the 0–255 scale. A highlight is pure white and contains no useful detail.

High value The lightest useful image, tone with a value of less than 255. Unlike an image highlight, a high value retains detail and information in the tone. High values can add beauty and subtlety to an image.

Histogram A graphical representation of the tones in an image. Displayed as a vertical bar chart with black on the left and white on the right, each column in the graph shows the number of pixels of a specific tonal value found in the image. Histograms are extremely useful in assessing an image.

ICC The International Colour Consortium (ICC) was founded by major manufacturers to establish and maintain colour standards and cross-platform systems.

Inkjet A printing method that sprays minute, various sized ink droplets on to a wide range of media. It is probably the commonest system of printing (especially in the field of fine art) now used outside the printing industry.

Interpolation A method of using two or more existing pixels in an image to form additional pixels. It is used to enlarge digital image files, but with the result that the image appears less sharp and less finely detailed.

ISO speed Photographic film and digital sensors are graded according to their sensitivity to light (using specifications laid down by the International Standards Organization) and given an ISO speed value. This is usually known as the 'film speed' or ISO speed.

Jaggies The stepped appearance of diagonal and curved edges in a pixel-based image when aliasing is not used.

JPEG A lossy compression algorithm devised by the Joint Photographic Experts Group for the efficient storage of photographic picture files. This compression system reduces image quality because it permanently removes some image data.

Kilobyte (KB) A kilobyte contains 1024 bytes of digital data.

Layer blending The method of controlling how each layer in a multi-layered image interacts with the layers below. In layer blending, various different Blending modes are used extensively to create special effects.

Layered image An image composed of two or more separate layers.

Layer opacity The transparency of an image layer. On a scale of 0–100%, layer opacity is used to control the visibility of the elements on the layer. Opacity is used extensively when controlling how different layered elements interact visually.

Layers Individual transparent 'digital sheets' that can be stacked, one on top of the other, and contain any type of image information. Adapted from the cartoon film industry, where the method of using transparent overlays is called 'onion skinning', layers permit the placing of different images on top of each other in any order to create complex montage and other effects.

Levels The graphic display of the brightness values in an image. The Levels can be used to set the density range and gamma of an image.

Line art A type of image that uses only one colour or tone, such as a pen and ink drawing, or a pencil sketch.

Low value The opposite of high value; low values are dark but not black, i.e. have a numeric value greater than 0. Low values retain some detail and can add depth and a sense of substance and quality to an image.

Megabyte (MB) A megabyte contains 1024 kilobytes of digital data.

Megapixel One megapixel equals around a million pixels. The term is used to describe the number of pixels produced by a digital camera. A 6-megapixel camera produces 6 million pixels of image data.

Usually, the higher the megapixel value, the bigger and better the image.

Nodes The adjustable points found on a vector path and used to adjust the curvature of the line as it passes through the node. Nodes have two handles, or anchor points, which can be moved to adjust the effect of the node on the path or line.

Noise Similar in appearance to traditional photographic film grain, noise is a by-product of using a digital camera set to a high ISO setting. Unlike traditional film, digital camera CCDs do not change as you increase the film speed. The speed increase is achieved by changing the 'gain' of the CCD which results in unwanted random coloured pixels appearing in deep-shadow areas.

Opacity The amount of the light absorbed by a tone in a negative or print. For example, if 100 units of light shine on a negative tone and only 50 units pass through, then the tone is said to have an opacity of 50%, or one half. See also Density.

Optical resolution This is the true measure of the sampling capability of a capture device, such as a scanner. The optical resolution is the number of individual data samples that the scanner head can make without resorting to software enhancements. The higher the number, the greater the image quality.

Pantone An internationally recognized system of identifying ink colours by a numerical system of codes. Used extensively in the printing industry, this system is used to guarantee colour fidelity for commercial use.

Path A vector-based (mathematically calculated) line that can be used to create very accurate outlines and selections in an image-editing program. Paths use nodes to control the shape of the line and can be infinitely adjusted and scaled without loss of quality.

Peripherals Pieces of external hardware equipment that are connected to (and used to extend) a computer system. The commonest peripherals are scanners and printers.

Perspective The visual inter-relationship of different objects when viewed from one static position.

Perspective in photography is controlled solely by the viewpoint used to make the picture. The term is also used to describe how visual and real lines converge towards the horizon (or vanishing points).

Pictography A type of imaging system, produced by Fuji, that uses special print media to produce photographic prints without the use of chemistry.

Pigment inks More light-fast and stable than dye-based inks, pigment inks have actual colour pigment suspended in a holding medium. Used for fine-art inkjet printing, pigment inks have a reduced colour gamut compared to dye inks.

Pixel The term 'pixel' is derived from 'picture element' and represents the smallest unit of a digital image.

Pixellation When the pixels of an image are large enough to be seen by the human eye, the picture looks 'blocky' and is said to be pixellated.

Profile A data file defining the colour reproduction characteristics of a colour imaging device such as a scanner or a printer. Profiles are used by colour management systems to ensure colour fidelity when image data is moved from one device to another, e.g. from the scanner to.the monitor and then to the printer.

Quadtone An image that contains four different colours and requires the same number of ink colours when reproduced in print. For accuracy, the colours are usually chosen from the Pantone system.

RAM RAM, or random access memory, is used as the temporary storage facility inside a computer, and is often called the main memory. 'Random access' means that any memory location can be read directly without having to read all the locations before it (as in sequential memory, now obsolete). RAM needs power to hold information, so when there is a power loss, all data in the RAM is lost.

Raster image An image composed of pixels. The raster format is used for photographic images. Raster files can only be scaled using interpolation, which reduces image quality.

Resolution The term 'resolution' is used in different ways. Basically, it is the input or output quality achievable with a particular image or device. Higher resolutions produce high-quality output. The resolution of an image is determined based on its intended use..

RGB image An image that uses the primary colours of Red, Green and Blue. Each primary colour has its own channel, and every individual coloured pixel in the image is formed by combining the three colour channel values for that pixel.

RIPs RIPs, or raster image processors, translate vector and font information into bitmap form so that they can be output on a raster device.

Scratch disk A portion of hard disk space reserved by the operating system for use as additional main memory when the RAM is full.

Selection An isolated region in an image, created using selection tools, that restricts the effect of changes to the image. See also Alpha Channels.

Shadow Any part of a photographic image that has a value less than middle grey (128) and contains useable detail i.e. not full black (a value greater than 0).

Shadow mask A type of fine, perforated screen that is used in computer monitors to generate the pixels seen on screen.

Sharpening A method of increasing the contrast of adjacent pixels to create the impression of increased sharpness.

Subtractive colour Used in the printing industry, subtractive synthesis uses the pigment primaries of Cyan, Magenta and Yellow and occurs when you add pigment printing inks together. Colours produced by adding primary inks together can only go darker than before and hence the colour is subtracting light. In theory, using CMY together should produce Black, but in reality it tends to result in a muddy dark brown colour. For this reason, Black is used to 'key' the dark tones of a printed image and hence the use of CMYK ('K' for Black) for image formats intended for books and magazines.

TIFF TIFF, or tagged image file format, is the most commonly used file type for the cross-platform compatibility of digital images. Generally used as a lossless compression method, there are variations of this format that use lossy compression, but these may not be compatible with all software.

Tritone An image that uses three colour channels to produce a toned effect. See also Duotone and Quadtone.

TWAIN TWAIN, or tookit without an interesting name (it's true!) is a universal software interface used by scanners and digital cameras to allow images to be acquired directly from within an image program.

Unsharp Mask filter (USM) The most popular method used for sharpening images is the Unsharp Mask filter. It is based on the traditional darkroom technique of increasing the sharpness of a soft image by combining it with a slightly out-of-focus, reversed-tone duplicate prior to printing.

USB USB, or universal serial bus, is a high-speed data transfer system, which is easy to use. It's a 'hot wire' system: this means that a USB peripheral can be plugged into and recognized by the computer system whilst the computer is switched on.

Vector graphics An image type composed of lines, curves and filled shapes, based on mathematical formulae. Due to its mathematical origin, a vector graphic can be scaled infinitely without any loss of quality. However, vector graphics cannot produce the subtlety of tone of a raster image.

White balance A software system used by digital cameras for obtaining accurate or natural colour without the use of special filters, when photographing subjects under various types of light source.

White out With a digital camera, if parts of the subject are very bright, such as the sun, overexposed areas will be produced with pixel values of 255. This is known as 'white out'. On traditional film negatives, such areas could often be printed down (burned in) to coax some detail out. With digital images this is not possible, because once the brightness of a pixel is 255, there is nothing there to coax out.

Index

Acknowledgements

All books are produced by a team effort that combines the knowledge and skills, from various disciplines, of several different people. This book is no different, so it is here that I am able to thank the other members of the team.

Sometimes the people involved are known to the author, but very often there are many others working in the background to get the book into print. Both to those I know, such as my Senior Editor Nicola Hodgson at Chrysalis Books, and to all those I will probably never know, I wish to pass on my thanks and gratitude for all the effort put into the making of *Digital Photography Problem Solver*.

Of course, special thanks must always go the family of the author, which in my case is my partner Barbara. Thanks m'dear!

I am always interested in your feedback and can be reached by email at les.meehan@zone2tone.co.uk.